# POWER MARKETING
## FOR WEDDING AND PORTRAIT PHOTOGRAPHERS

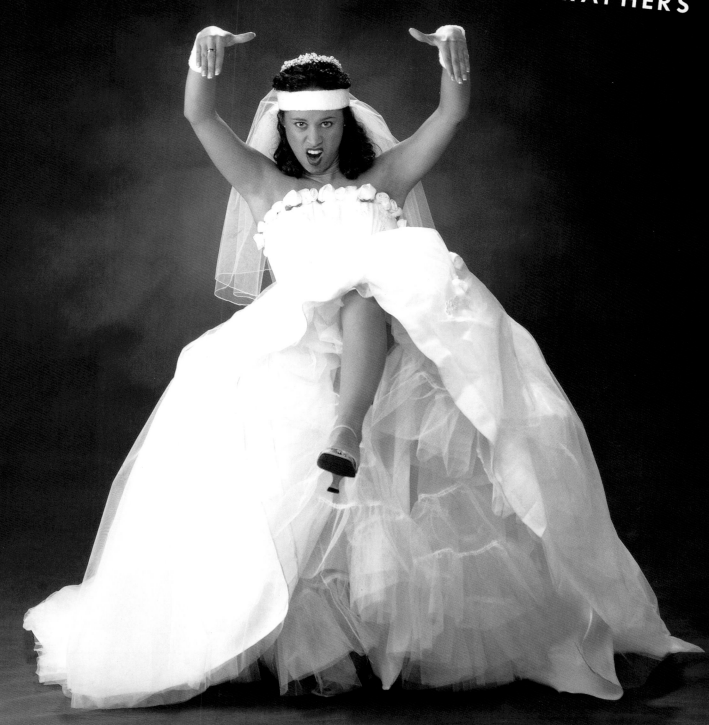

**MITCHE GRAF**

AMHERST MEDIA, INC. ■ BUFFALO, NY

Photography Credits:
Front cover, page 1, plus interior images from the "karate bride" and "power-lifting bride" series by Mark Huender. Author photo and power-corner contributor photos by: Gary Scott (page 6, portrait of Mitche Graf); Doug Box (page 88, self portrait); Tom Danielson (page 119, portrait of Skip Cohen); John Hartman (page 9, self portrait); Cheri Lewis (page 70, portrait of Charles Lewis); Charles Maring (page 108, portrait of Jeff and Kathleen Hawkins); Susan Michal (page 84, portrait of Rick Ferro and Deborah Lynn Ferro); Peggy Redford (page 21, portrait of Michael Redford); Sue Tunnicliffe (page 41, portrait of Don McGregor); Michael VanAuken (page 46, portrait of Bambi Cantrell). Page 19 photograph of Mike Strickland by Ty Boyce. Page 38 photo by Bill Winter. Page 56 photo by Steve Mackley. Page 95 photos by Mark Huender. All other images by Mitche Graf.

Published by:
Amherst Media, Inc.
P.O. Box 586
Buffalo, N.Y. 14226
Fax: 716-874-4508
www.AmherstMedia.com

Publisher: Craig Alesse
Senior Editor/Production Manager: Michelle Perkins
Assistant Editor: Barbara A. Lynch-Johnt

ISBN: 1-58428-136-7
Library of Congress Card Catalog Number: 2003112492

Printed in Korea.
10 9 8 7 6 5 4 3 2 1

---

**ABOUT THE COVER:**

Concept—Mitche Graf; Photography—Mark Huender (The Big Picture, Coeur d'Alene, Idaho); Model—Jaime Johnson; Dress—Affordable Elegance (Coeur d'Alene, Idaho, 208-664-8847)

# DEDICATION

I would like to dedicate this book to one of the greatest men I have ever met, Pat Wright. Although he is no longer with us, he left behind a legacy that will not soon be forgotten. As my stepfather, my supporter, and my friend, he showed me the value of not only a hard days' work, but also the importance of taking time to enjoy the precious moments life has to offer.

By example, he taught me to take my work seriously, but to take myself lightly. His playful spirit will forever be an integral part of my daily life, and his gentle approach to loving others will always help guide me in each of my relationships. I am honored to have known such a tender and loving man.

# TABLE OF CONTENTS

**ABOUT THE AUTHOR** . . . . . . . . . . . . . . . .6

**INTRODUCTION** . . . . . . . . . . . . . . . . . . . . .7
Motivations . . . . . . . . . . . . . . . . . . . . . . . . . .7
About the Power Corners . . . . . . . . . . . . . . . .8

POWER CORNER:
FOCUS ON JOHN HARTMAN . . . . . . . . . . .9

**1. THE WONDERFUL WORLD OF
    MARKETING** . . . . . . . . . . . . . . . . . .15
What is "Power Marketing"? . . . . . . . . . . . . .17
The Power Marketing Self-Test . . . . . . . . . . .18

POWER CORNER:
FOCUS ON MICHAEL REDFORD . . . . . . .21

**2. DEVELOPING YOUR MARKETING
    STRATEGY** . . . . . . . . . . . . . . . . . . .25
Taking It All in Stride . . . . . . . . . . . . . . . . .25
    Brainstorming . . . . . . . . . . . . . . . . . . . . .28
Making Progress . . . . . . . . . . . . . . . . . . . . .30

Understanding Your Customers . . . . . . . . .30
Identifying Your Hook . . . . . . . . . . . . . . . .31
Establishing Program Goals
    and Objectives . . . . . . . . . . . . . . . . . . .40

POWER CORNER:
FOCUS ON DON MACGREGOR . . . . . . . .41

POWER CORNER:
FOCUS ON BAMBI CANTRELL . . . . . . . .46

**3. POSITIONING FOR PROFIT** . . . . . . . . .53
Finding Your Niche . . . . . . . . . . . . . . . . . . .55

**4. THE TEN CATEGORIES OF POWER
    MARKETING** . . . . . . . . . . . . . . . . . .57
    1. Literature . . . . . . . . . . . . . . . . . . . . . .57
    2. Curb Appeal . . . . . . . . . . . . . . . . . . . .58
    3. The World Wide Web . . . . . . . . . . . . .58
    4. Advertising . . . . . . . . . . . . . . . . . . . . .60
    5. Pricing . . . . . . . . . . . . . . . . . . . . . . . .60
    6. Press Releases . . . . . . . . . . . . . . . . . . .62

7. Time . . . . . . . . . . . . . . . . . . . . .62

8. Referral Network . . . . . . . . . . .63

9. Database/Direct-Mail Marketing . . . . .67

10. Phone . . . . . . . . . . . . . . . . . . . .67

POWER CORNER:
FOCUS ON CHARLES LEWIS . . . . . . . . .70

## 5. CREATING VALUE— REAL OR PERCEIVED . . . . . . . . .78

Defining Value . . . . . . . . . . . . . . . . . . .78

Enhancing Perceived Value . . . . . . . . . . . .79

POWER CORNER:
FOCUS ON RICK FERRO AND
DEBORAH LYNN FERRO . . . . . . . . . . . .84

POWER CORNER:
FOCUS ON DOUG BOX . . . . . . . . . . . . .88

## 6. IMAGE IS EVERYTHING . . . . . . . . . .94

The Five Biggest Mistakes
Photographers Make . . . . . . . . . . . . .97

1. Failure to Have a Well-Thought-Out
Marketing Plan . . . . . . . . . . . . . . . .97

2. Failure to Have a Clearly Defined
Hook or Message . . . . . . . . . . . . . . .97

3. Failure to Have Professional-Looking
Marketing Pieces . . . . . . . . . . . . . . .97

4. Failure to Project Your Sales and
Goals Into the Future . . . . . . . . . . . .97

5. Failure to Price Your Packages to
Allow for Costs, Overhead, and that
Four-Letter Word: Profit . . . . . . . . . .98

The Five-Second Image Challenge . . . . . . . .100

Step 1: The Image Inventory . . . . . . . . .101

Step 2: The Physical Inventory . . . . . . . .102

Step 3: The Marketing Inventory . . . . . .105

POWER CORNER:
FOCUS ON JEFF AND
KATHLEEN HAWKINS . . . . . . . . . . . . .108

## 7. SPECIAL REPORT! MITCHE'S TWELVE-STEP PROGRAM . . . . . .112

POWER CORNER:
FOCUS ON SKIP COHEN . . . . . . . . . . . .119

## CONCLUSION . . . . . . . . . . . . . . . . . . . .122

## INDEX . . . . . . . . . . . . . . . . . . . . . .123

# ABOUT THE AUTHOR

Noted speaker and author Mitche Graf has worked in the field of sales and marketing for over twenty years and has been involved in many exciting business ventures—from a used bike parts business he ran from his garage in seventh grade, to a cribbage board manufacturing company, to a limousine business, to a portable hot-tub rental business, and a drive-through espresso business. In 1996, he opened Graf Photography in a small Northern Idaho town with a population of only 2,400 people—a decision that has challenged Mitche to refine his marketing skills.

In his free time, Mitche enjoys the outdoors, gardening, playing guitar, listening to music, reading, barbequing, and spending time with his family. He firmly believes that life is meant to be lived, not endured, and that we each have the ability to make a difference in the world. He loves his family and his friends—and the rest just falls into place!

Mitche believes that the basic principles of marketing are the same whether you are selling meat, corn, bricks, or photography. Through his successes and failures, he has continued to make bold attempts to redefine the limits of his abilities. Whether you live in a small town or a metropolitan area, you'll find in this book the techniques you need to maximize your success.

For more information on Mitche Graf or his educational workshops and seminars, visit www.mitchegraf.com, or call (888)544-4149.

# INTRODUCTION

I am excited to spend some time with you, and I hope you are just as excited to immerse yourself in the field of marketing. The fact that you are investing your time in this book shows that you are one of the few who will make a difference in our industry. I welcome and congratulate you!

In today's overcrowded marketplace, we have more choices and are faced with more decisions than ever before. How do we decide what we should spend our hard-earned money on? In 1980 there were 400 mutual funds; today there are over 10,000. In 1980 alone, 1,500 new grocery products hit the shelves; this year there will be over 15,000. With all these choices, you have to offer something the buyers in your target demographic can't get from anyone else. You need a marketing game plan that is brilliant in its simplicity.

The journey you are about to take is going to change your life forever! While that's a big statement, I guarantee that if you take the marketing principles outlined here seriously, you will tap into a better way of looking at your business and a better quality of life. And that's important. After all, photography is not who we are, it's only what we do.

## ● MOTIVATIONS

What is the number one reason for starting your own business? Is it the joy of being a self-employed entrepreneur and an ability to dictate your own hours? Is it the money? The ability to dream your own dreams and reach for the stars? Is it the ability to "breathe life" into your own business creation and watch as it grows and becomes more profitable and successful over time?

Actually, each of these ideals prompt people to put everything on the line and start their own business. However, the number one reason is that we have a passion for what we do!

I assume that since you are reading this book, you are a professional photographer or are committed to becoming one. That said, I suspect you are technically proficient and can take pretty good pictures. Therefore, this book doesn't cover posing, lighting, camera equipment, or the latest advances in digital

technologies. Instead, it is dedicated to getting you fired up and excited about what I call the "fun stuff."

During our time together, you'll challenge your mind, get your creative juices flowing, and turbocharge your studio in fresh, innovative ways. I'll teach you how to make your phone ring and make more money, and that will give you more time off to do the things that are most important to you. As a result, you'll enjoy a renewed vigor in your personal life.

*We end up running our studios instead of designing our lives.*

It's easy to fall into that old management trap and get caught up in the day-to-day business details. We end up running our studios instead of designing our lives. We answer phones, mask negatives, order supplies, clean the bathroom, and mow the lawn. Before we know it, we are working seven days a week, sixteen hours a day—week after week, month after month. We don't have time for our families, to drop a fishing line in the water, to hit that golf ball up and down the fairway, or to watch our favorite show on the weekend. The things that are most important to us start slowly slipping away, and we become a slave to our business rather than its master.

If you are like most other professional photographers, you are looking for effective and innovative marketing techniques that will take your business to the next level of sales and profitability and give you the freedom to attain your goals in life. *Power Marketing for Wedding and Portrait Photographers* will teach you dynamic, profit-oriented methods to not only compete in the battle for customers, but to win the marketing war! The strong will survive, and the weak will perish. Which will you be?

## ● ABOUT THE POWER CORNERS

Between the chapters in this book, you'll find sections called "Power Corners." When I began to write this book, I knew I wanted to not only share with you the thoughts that were rattling around in my brain, but to also bring you ideas and inspirations from the best marketers our industry has to offer. I proceeded to assemble a team of photographers and marketers who were willing to open up and talk about their lives, both personal and professional. Some of these interviews were done via telephone, others were done through e-mail, and still others were conducted in person.

Each person was presented with basically the same set of questions, and they responded in their own unique way. You will notice, however, that even though the answers, approach to life, and perspectives are all a little different, there is a common thread that ties them all together. They individually believe that life is to be lived to its fullest, and photography is but a means to that end.

These contributors are marketers first and photographers second. They do not let their business get in the way of their lives—and there is definitely a lesson for us all in that example. Effective marketing allows you to have a life outside of photography!

Besides wanting to find out what makes them tick professionally, I wanted to dig deeper and discover who they are as human beings. They all were good sports about it! The time I spent talking with each of these successful photographers was perhaps the best education I have received in this industry! It motivated and inspired me, and it confirmed in my mind that successful people have the same things in common.

I know you will enjoy the nuggets of wisdom they have to share with you—so let's get started right away! The first "Power Corner" begins on the facing page.

## FOCUS ON . . .
## JOHN HARTMAN

John has his business and his life figured out! He has kept a fresh attitude during his thirty-year photographic career by building a business that serves him, rather than the other way around.

This arrangement affords him time to help other photographers by producing business-building seminars (the John Hartman Marketing Boot Camp), creativity-enhancing products (Quick-Mats™ digital matting system), digital workflow solutions (QuickProofs™), and marketing and sales systems (SeniorMarketing™). His famous "Marketing Boot Camps" are an absolute must for anyone looking to gain a complete understanding of what marketing entails.

For more information on John's educational materials and seminars, visit www.jhartman.com.

**Mitche: What is the biggest challenge facing our industry in the coming years?**
*John:* Like many other industries, the electronic revolution is changing the methods by which we do business, and it is most likely changing our whole business model. The way we shoot, present our images, sell, and produce photographs will never be the same. Similarly, the methodologies we use to locate, sell, and manage our customers have never been more complex. The challenges can be met by flexible, forward-thinking, customer-driven studios. Those that cannot or will not adapt to these changes will eventually die, most likely sooner rather than later.

**Describe your marketing philosophy.**
Marketing is simply a communication system to drive clients into your studio. The best marketing is that which creates the maximum number of qualified customers at the lowest possible cost and effort per total sales. Note that I did not simply say the lowest possible cost. Marketing that brings in a high response might be expensive to produce, but *because* the response rate is so high, the result is a very low marketing cost as a percentage of total sales.

To illustrate, one photographer among my senior marketing clients spent $1,200 on a postcard mailing that produced eight phone inquires, resulting in three confirmed portrait bookings. Those three sessions brought in a total of $2,258 in sales. His marketing cost as a percentage of sales was a rather dismal 53 percent, and, in his opinion and mine, certainly was not worth his time and effort.

He then switched to a more comprehensive mailing strategy which contained an eight-page sales letter, combined with an eight-page color catalog mailed together in a 9x12-inch envelope. Printing and mailing costs for this package were just over $5,300. He mailed to the same list and this time

booked 154 sessions with total sales of $109,494. His marketing costs as a percentage of sales was under 4.8 percent.

At first, he was petrified at the thought of spending $5,300 at his printer and post office ("I could've bought a new digital camera and a couple of lenses for that!"), but his spectacular results helped to change his attitude. Good marketing is not an expense; it's an investment. For him, every dollar spent returned $20.00. At that rate, how much would he have been willing to invest? As much as possible!

Another portion of my thinking about marketing is that it should be a tool to keep your studio running as close to full capacity as possible, for as long as you deem necessary. If you have a large staff that likes to get a paycheck every week, you may deem fifty-two weeks a year to be necessary. If you're a mom-and-pop studio and like time off, you may be able to earn a good living working hard just twenty to twenty-five weeks a year.

Regardless, marketing keeps your schedule from being a hit-or-miss affair. If you are as busy as you want to be, with no holes in your schedule, then your marketing is working. If you aren't shooting as many weeks a year as you'd like, or if your schedule has 9:30 a.m., 1:00 p.m., and 4:30 p.m. appointments with nothing in between, then your marketing probably needs some fine-tuning.

**What do you feel are the most important attributes of a "Power Marketer"?**
The Power Marketer understands what marketing is and what it can do for his or her studio [see example above]. A key attribute of the Power Marketer is the ability to see the big picture while being able to focus on details of the here and now (hence my self-

> *"Marketing keeps your schedule from being a hit-or-miss affair."*

portrait). Power Marketers constantly test new marketing ideas against old, proven ones and don't change until they have found ones that work better, faster, cheaper or with greater yield. Most photographers jump willy-nilly into a new marketing idea they haven't even tested, often abandoning the successful marketing they had been using. The Power Marketer knows that marketing that works should only be substituted with marketing that works *better*. And the most powerful of Power Marketers will often use these new marketing ideas in tandem *with* their old ones, rather than substituting them.

Doing this allows each studio to build business in its own way, and to compound their marketing results.

**Do you feel that Power Marketers are born, or are they self-taught?**
Some people have the gift of interpersonal communication, which is often called "born salesmanship." To some extent this is true, but born salespeople do not necessarily make born Power Marketers. Marketing is both an art and a science that requires several abilities and skills.

First is the ability to provide interesting products and services for which customers are willing to pay the price you need to get in order to maintain your standard of living—and make sure you're still in business tomorrow. It's not impossible to market a bad product, but it makes the task much more difficult, especially if you rely on repeat business.

Second is the ability to realize that without a customer, you do not have a photography studio, but merely an art gallery. The *only* way to create customers is through marketing. And the more effective your marketing is, the faster your business grows,

and ultimately the faster you will achieve the lifestyle you desire.

Third, Power Marketers understand the reasons that customers do business with them, and from those reasons they develop their hook or unique selling propositions (USPs) to market to their new prospective clients. They constantly query their clients on why they chose their studio over others and then promote those reasons in their marketing. They don't waste marketing space tooting their own horns, but rather, they place a high priority on packing as many customer benefits into their marketing effort as possible. They fully understand that people don't buy photography; they buy the benefits that photography brings them, whatever they may be.

**What are the most important things in your life, and how does your marketing come into play with those things?**
My family, my God, my friends, and my personal development as a contributing human being in the days allotted to me on terra firma are my life priorities. Smart marketing has allowed me time and resources to spend on them, instead of being a slave to my business.

**How important is it to you to have the proper balance between your personal and professional life?**
Most people spend a good portion (if not all) of their life buying money with their time. Some people tire of this early (I did at age eighteen) and learn it is much more efficient to buy time with your money. I do this by delegation. I know what the value of my time is, and if there is someone who is willing to do a job that needs to be done at a lower cost, then I buy that time from them. The more I can delegate, even into my personal life, the more personal time I have. You rarely "save" money by doing it yourself if you factor in the value of your time. This realization has changed both my personal and professional life in a very positive way.

**What two things would you recommend to someone who is looking to take their marketing to the next level?**
(1) Marketing is not a one-shot affair. Its effectiveness can only be measured with repeated efforts and exposures to a targeted prospective clientele. People are not always ready to buy at the exact instant your marketing reaches them. But given enough exposure to your message, they will buy from you when the need for your services finally arises. (2) Don't overlook the most obvious and valuable marketing resource you possess: your current customer base. It costs about twenty times more to acquire a new customer than it does to reactivate an old one. For some reason many photographers think their first-time customers are finished buying from them. Nothing could be farther from the truth; they can buy more (up-sell or reorder from existing files), they can buy again (resell or update session), or they can buy something else (cross-sell or migrate to a new product line). These people have already done business with you; they like what you do, they understand your fee structure. Provide good WIIFM (what's-in-it-for-me) reasons to spend money with you again and, more often than not, they will.

**What is your "hook"?**
For my photography clients, it's "You get a comfortable and enjoyable session, flattering photographs, and finished image products you will be proud to

> "The more
> I can delegate,
> the more personal
> time I have."

hang in your home and give to friends and loved ones—guaranteed."

For my photographer clients, it's "We provide marketing, sales, management and digital workflow solutions that bring additional sessions, higher sales, and time savings all out of proportion to their investment."

**What marketing campaign or concept has been the most productive and successful for you?**
Far and away, the best marketing vehicle I have used is direct mail. I've had a single portrait mailing to 4,000 prospects bring in over $200,000 in sales within one six-week period. One direct mail piece to photographers resulted in over $33,000 in sales in a single morning. I designed, printed, and sent a mailing to several hundred of my past portrait clients that resulted in over $6,000 in credit card deposits within forty-eight hours of the mailing.

No other marketing vehicle I've used even comes close to this kind of response. I continue to test Internet marketing, rep marketing, and joint ventures with other businesses, but for fast, immediate sales, direct mail is still king.

**What about the least successful?**
Yellow pages advertising. I tracked results three years running and found that although the ad produced many inquiries, most were unqualified price shoppers who spent lots of time asking questions but rarely were converted into paying customers. Not only was the actual dollar investment of the ad wasted, so was a large amount of staff time. In not one of those three years did the sales from those yellow pages ad clients pay for the ad. Dropping to a simple line listing was an easy sell to the ad rep.

**What do you do for fun?**
I have a loving wife and three sons—ages twenty, sixteen, and nine—who require (and receive) lots of my attention. Luckily we all share interesting passions: music (I'm a former professional drummer), gourmet cooking, biking, and downhill skiing. My personal passions are fast cars and investing (you need the latter in order to do the former). And of course I still love to pick up a camera and shoot just for me—that I will never classify as work.

Having helped literally thousands of photographers grow their studios over the past twenty years, I think I can safely say that there are some that "get it" about marketing, while most others do not. Because you are reading this book, you either already "get it" or at least soon will. The time spent studying and emulating successful marketing ideas is the most valuable investment you can make in your business.

Take away all my photography skills, my Photoshop knowledge, indeed my entire studio, but let me keep me my marketing skills, and I'll have it all back in no time. Take away my marketing skills and I'll be stuck at the bottom of the barrel until the bankruptcy court finally calls. The choices you make right now about where to take your business will determine where you will be one year, five years from now, right up to the end of your career. Choose wisely.

> "The best marketing vehicle I have used is direct mail."

**What is your favorite food?**
My teenager, an aspiring–gourmet cook, makes a mean Chicken Vesuvio from Harry Carey's in Chicago that's currently on my A-list.

**Favorite movie?**
*Vanishing Point*, a 1971 cult classic (I'm showing my age here!).

**Favorite book?**

*The E-Myth* by Michael Gerber.

**What's the best experience you have had in your life?**

Besides being present at the births of my three sons, it was pretty cool to step out of a 40-foot stretch HumVee limo with the Blue Man Group, my staff and seven photographers/musicians in front of the Luxor in Las Vegas (to the cheers and camera flashes of several hundred students posing as "fans") at Boot Camp in 2002. They pulled off the entire evening including a huge party and my getting to play with the band, without me having a clue. That evening I learned the depth of the camaraderie that exists in this industry, and what a privilege it is to be a part of it.

> "I learned the depth of the camaraderie that exists in this industry."

**Who are your biggest inspirations in your life as a photographer/teacher/entrepreneur?**

Paul Castle taught me that it's about business, not about photography. Don Feltner showed me how to build that business faster than I ever dreamed possible. Charles Lewis gave me the inspiration to grow outside of my box. Earle Nightengale proved it's not what happens, but what you do about it that matters. Jay Abraham has to be the most creative thinker in the business world. My wife Kathy, who always reminds me that it's nice to be important, but it's more important to be nice!

# 1.
# THE WONDERFUL WORLD OF POWER MARKETING

So, what does the word *marketing* mean to you? Simply defined, it means letting potential customers know who you are, what you do, and why they should spend their hard-earned money on your product/services. While the concept is a simple one, many businesspeople put little effort into achieving these goals. They open their doors in the morning and wait for clients to come through the door. Well, I prefer to have control over my business, and I believe you do, too.

To succeed in this industry, you'll need more than a love of photography. You must have a basic understanding of the laws of business and a marketing plan that's second to none! It also demands initiative, self-discipline, and a tremendous amount of mental energy drawn from the depths of your creative being. Small business owners have gigantic challenges to face each and every day, whether it be the increasing costs of doing business, more competition for consumer dollars, regulations from the government, or the need to find the energy to keep your nose to the grindstone when things get tough.

I don't know about you, but I'm self-employed so I can have more time off and the financial means to fully appreciate that time! And that's where marketing comes in. Having a solid marketing plan will allow you to do the things in life that are most important to you.

You always hear people talking about managing time. Well, you can't *manage* time, you can only decide how to *spend* your time. We sometimes forget that running a successful studio requires a lot more than the day-to-day routine; it requires the vision as well—the stuff from which dreams are made. It's almost mystical as it drives us each and every day to get up and do a better job than we did the day before. It's what we have that others lack.

Whether you live in a thriving metropolis or in a small town, having a well-defined marketing plan is vital to your professional success. Did you know that every ten seconds in this country there is a business that folds up its tent and goes home? That's an amazing statistic! In five years, four out of five photographers probably won't be around. And guess what

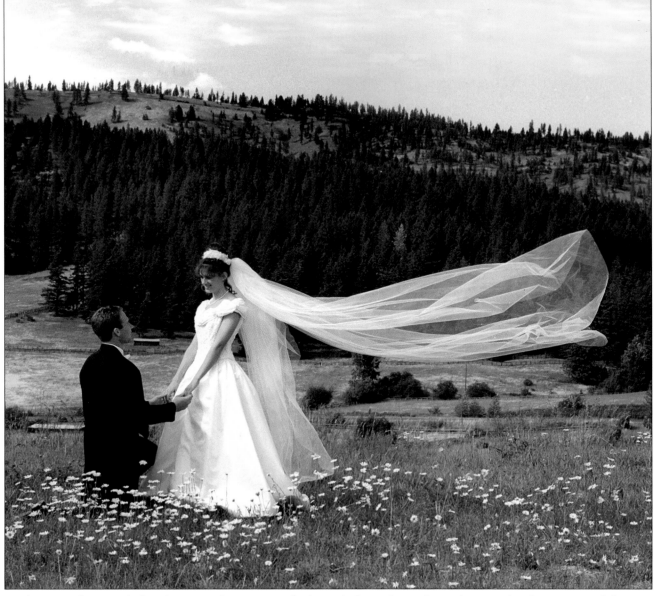

In photography, people buy because they want to feel good about themselves. They need to be convinced that we offer something special that will add value to their lives.

most of those photographers don't have? You guessed it—a marketing plan.

I live in a small town, like many of you. My town has a population of about 2,400 people. It is predominantly a timber town, which means that we have a very high unemployment rate of anywhere from 14 to 18 percent. This in and of itself creates a new set of obstacles and problems for the small business owner. Entrepreneurs are faced with more and more challenges and obstacles every day. There are times you just want to beat your head against the wall and chuck it all in. That's because we allow our businesses to control us instead of us controlling our business. We need to work hard, play hard, love our families, and love our friends. The rest will fall into place.

Here's the question: If you only had a limited amount of time to live, would you work less than you do now? Would you play more? Would you spend more time with loved ones?

I hate to be the bearer of bad news, but things are not getting any easier for professional photographers. Whether you realize it or not, you already have a marketing plan. It begins the first time some-

one hears your name, sees your signs, hears your voice on the phone, or walks into your place of business. Marketing is how you create value for yourself and for your products. It creates a demand for your product long before the phone ever rings or the client walk in the door.

It has been said that the sales process ends when the client writes you a check. Well, everything that happens up to that point determines how large that check will be. That's where the marketing comes in. The better job we do in marketing, the bigger that check is going to be. Marketing is not rocket science, but the lack of a well-planned strategy is one of the biggest reasons why studios fail. The best product doesn't always win the race. The best marketer does.

You are better off being a good photographer and a top-notch marketer than the reverse. My money is on the marketer every time! In photography, people buy because they want to feel good about themselves. They need to be convinced that we offer something special that will add value to their lives.

### ● WHAT IS "POWER MARKETING"?

So, what is Power Marketing? Actually, it's the exact opposite of passive marketing. It demands your personal, proactive involvement and is very systematic. If you want to be a successful Power Marketer, you must be willing to roll up your sleeves, jump in the trenches, and get a little dirty! Sounds like fun, doesn't it? It really can be if you understand the philosophy behind it and can see the benefits you will reap over the long haul.

I once knew a man who owned a successful pet-product manufacturing company, and it seemed no matter what pet store I went into, his product was on the shelf. The packaging was professional looking and colorful, the price

*Roll up your sleeves, jump in the trenches, and get a little dirty!*

was fair, and it was something every pet owner used. What better combination, huh? My opinion of the product was so high that I figured his warehouse was full of brand new, high-tech equipment, the employees dressed in freshly pressed uniforms, and the offices lined with expensive oak furniture.

I remember walking into his building for the first time and feeling my jaw drop to the floor. The building was actually an oversized garage, there were only three employees (most of the work was contracted out) and the "executive office" was a remodeled bathroom with little room to sit. There were file cabinets everywhere (organized alphabetically of course), a small coffee table with one magazine, and two chairs. It was a very clean and organized office, but it was tiny!

I couldn't believe such a "big" company was operating out of such a small area. When I asked him how he had made his company so successful though he was working with so little, his answer was short and to the point—"Marketing, marketing, marketing!" Although he didn't believe in excessive spending, he spared no expense when it came to presenting a professional image to his customers. Everything from the way his secretary answered the phone, to his elegant letterhead, to the way he packaged and presented his product was top-notch. He settled for nothing but the best, and nothing was left to chance. I remember him telling me that image was the most powerful marketing element, and the only thing that mattered was what the customer thought. His marketing plans were written out a year in advance, and he could show you the results from each and every idea he ever tried, good or bad! If something didn't work, he would either rework it and try it again or move on to something else until he got it right!

The last time I talked with him, his annual sales were over $10,000,000. There is something to this thing they call marketing.

### ● THE POWER MARKETING SELF-TEST

Before you dive in with both feet, you need to take inventory of your current marketing efforts. So, let's begin with a quick Power Marketing self-test. I can

A solid foundation is necessary to reap positive results and attain the goals we have set for ourselves.

hear the gasping out there, but don't worry—there are no wrong answers to this test, it's just information about your business (and the more information you have, the better prepared you will be when it comes to planning and initiating a power-marketing campaign).

Now, you may not have answers to all of the questions in the following test. Don't worry. Simply providing any answers you can will help you to lay the foundation for a new way of thinking. Creating a marketing plan is similar to building a house: A good contractor would never build a house on unstable ground or without pouring the concrete first.

A solid marketing foundation is necessary in order to reap positive results and attain the goals we have set for ourselves. I do my best not to let my business run my life. I used to work six to seven days per week, fourteen hours per day, but I realized life is way too short and precious, and I needed to rearrange my priorities. The reason I run my own business and work hard is to have financially secure time off! Isn't this a goal we all should have, to be able to enjoy the fruits of our labor? Sure, there are times we need to spend long hours at work—occasionally for days on end. Then, there are times we can put a big X through an entire Friday on the calender and take a three-day or even a four-day weekend, or even an entire week!

So grab your favorite beverage and a pen and notepad. Unplug the phone, put some relaxing music on, then sit back, close your eyes, and relax for a few seconds before we begin.

All right, here we go . . .

1. What do your current marketing efforts consist of (e.g., yellow pages, direct mail, newspaper, magazine, or television ads, mall displays, vendor networks, senior referral programs, etc.)?

2. Do you have a way of tracking the results of your current programs? What is it?

## THE LEGEND OF THE MOUSE

"I only hope that we don't lose sight of one thing … that it was all started by a mouse."

—Walt Disney

Since 1928 when Steamboat Willie debuted the name, the Walt Disney Company has always stood for excellence. Whether it's the newest cast member or one with over forty years of experience, all the employees are passionate about making magic happen. As a photographer for the Walt Disney Company, that magic takes place each and every day I come to work!

Walt Disney and Mickey Mouse are arguably the most widely recognized names in the world, and the mere mention of their names creates a spark to our imagination and brings a smile to our faces.

Over the past 100 years, Walt Disney has had themes such as "Remember the Magic," "100 Years of Magic," and now "Where Magic Lives." When a bride and groom come to us to photograph their wedding day, they expect us to capture some of that magic, just for them. Ever since they were little girls playing dress-up, they imagined the glass coach, the handsome prince, and the beautiful castle as the ideal place for their own wedding. Let me tell you, when they hire a Walt Disney photographer to photograph their wedding, that's pressure! Their wedding must be as magical as the fairytale the bride has imagined.

I have been a photographer at Walt Disney World™ for ten years. In that time I have photographed approximately 3,500 weddings, 1,200 Magic Kingdom™ Bridal Portraits and an equal number of family portraits, conventions, and commercial assignments. I constantly need to remind myself that it is the client's first time to be exposed to the Magic Kingdom, even though I have taken tens of thousands of exposures.

We need to constantly expand our knowledge and imagination if we expect to continue to exceed the expectations of our brides and grooms.

Walt Disney also said, "All you have to do is own up to your ignorance honestly, and you will find people who are eager to fill your head with information." And might I add imagination!

—*Mike Strickland, Director of Photographers, Walt Disney Co.*

3. Do you consistently develop a list of goals before you begin a new program? How do you do it? How do you measure their effectiveness?

4. What have you tried in the past that didn't attain the desired results? Why?

5. What programs in the past exceeded your desired results? Why?

6. Do you have a plan for your upcoming marketing programs? What are your plans?

7. Have you identified the goals and objectives of those programs? What are they?

8. What types of marketing are your competitors using that seem to be successful? Why?

9. Do you have a budget set each and every month for marketing? How much is it?

10. What makes clients come to your business

instead of to other studios in your area?

11. What makes them go to your competitors instead?

12. As a consumer, what would you look for from a professional photographer? Do you offer those things?

13. What are your three biggest strengths as a business owner? As a photographer?

14. What are your three biggest weaknesses as a business owner? As a photographer?

15. Do you set aside time each and every day to work on the essence of your business and to develop new ways to improve it? If not, what time of day would work best if you were to start this tomorrow?

Well, how did you do? Did you have a pretty good idea of how to answer each question, or did a few of them give you pause for thought? Remember, there are no right or wrong answers, only information. I challenge you to ask yourself not only these questions, but to come up with some of your own questions about your business and your effectiveness as a marketer. A top-notch Power Marketer is constantly reviewing, analyzing, and adjusting their techniques to achieve their maximum potential and to get the most out of their employees and their business. Only you have that ultimate responsibility! If you don't do it, nobody else will.

The only thing that mattered was what the customer thought.

Whether you have been in the industry for several years or have recently decided to jump in with both feet, you probably realize that it takes guts and determination to own and operate a business. If it were easy, everyone in the world would do it, but simple it's not! It requires a very special person who is willing to take risks, commit themselves to a cause, and to fight the daily battles in order to win the war. Most importantly, you must be willing to do whatever it takes to become successful. You are obviously one of the chosen few!

If I were to list all the issues that contribute to business failure, it would fill this entire book. Of course, you can find thousands of books on hundreds of subjects pertaining to business at your local library, through mail-order catalogs, or through the Internet. Many offer good information, but many do not. I know of only one absolute fact when it comes to operating a business: there is not another business exactly like yours in the entire world, and only you can decide what information is beneficial and what isn't. The following chapters will help you to tailor your marketing efforts to meet your personal goals and enhance your unique business.

But first, let's look at some suggestions from another Power Marketer . . .

## FOCUS ON . . .
## MICHAEL REDFORD

If you want energy, spend some time studying with Michael Redford! His powerful presence and witty sense of humor will stimulate your out-of-the-box thinking and give you a new zest for life! What started out as a fifteen-minute interview turned into a two-hour discussion on the wonderful world of marketing and photography. He has reinforced in me the value of hard work, and that you get out of life exactly what you put in!

In the early '80s, Michael began developing his marketing techniques (now revered as state of the art). Soon, utilizing the marketing systems and sales strategies discussed in-depth during his seminars, he had turned a small studio into a portrait "super studio" grossing over $1,200,000 per year.

Michael has blazed the marketing trail and has taken many arrows over the years. He now has the tried-and-true map to portrait studio success and to maintaining his quality of life.

For more information on his seminars and educational materials, visit www.redfordseminars.com.

**Mitche: What do you feel is the biggest challenge not only facing the industry, but also facing your business in the coming years?**
*Michael:* You know what, Mitche, I don't see many challenges. I've gotten to the point of nirvana. Nirvana means there's not much in front of it. I can do anything I want to do. Quite frankly, after you've put your mind to work over twenty years, and you've really worked and you've boot-strapped everything, you can face so many challenges. You don't look at life as like challenges, you just look at what's next. You know, "What do I want to do next?" I mean, I'm just so free to think that way that I don't see things as challenges. That's the honest-to-God truth.

**That's wonderful!**
I don't think of these being challenges as much as a need to keep yourself healthy enough to enjoy the whole thing.

**Now, over the twenty-plus years of experience you've had, describe what your marketing philosophy is. What are your core marketing concepts?**
The main point is that marketing is the engine of a business. When I want business, I market. When business goes down, I market. When my numbers aren't where they should be, it's because I didn't do my marketing. It's like marketing is the fuel of the business, and so throughout the years I've found out what fuel works best, and what's the best octane.

**What are the most important attributes of a Power Marketer?**
Learning how to network. Learning how to make friends. Learning how to get in touch with people that can help your business grow. Learning which people they are. Learning your target market. What is your target market? Who they are? And finding who you want to deal with—then learning how to

talk with people and talking to the ones who can put you in touch with the end result that you're looking for.

**Out of everything that you do in life, everything that you have, what are the most important things to you, and how does your marketing come into play with those priorities?**

Quality of life is everything to me. Where I sleep, how I sleep. Where I travel, how I travel. How my children are, of course, the success of my children. The most important thing is quality of life. And how does marketing relate to that? The better I market, the better quality of life I have. I truly, truly believe that marketing is the essence of quality of life regarding business and certainly portrait photography. You have to learn how to do business, but once that's all done, what makes it all function is the marketing. It all starts with marketing. The phone doesn't ring unless you've asked for business. The definition of marketing, in my opinion, is asking for more business. And after you've learned that, then the question becomes how to ask for the best quality of business.

**With the amount of time you put in at the office and at home, and everything else you do, how do you balance everything?**

I just work until I'm tired of working, and then I do something else. It's all about quality of life. First of all, do I get eight to ten hours of sleep? Yes, because that's part of the quality of life. The reason I chose photography is that I don't have to get up at 6:00 or 7:00 a.m. I don't do that. I wake up at 8:00 or 9:00 a.m., and I gently get up and go about working. And when I'm done working for the day and I've accom-

plished all that I have to respond to, I go and do my social stuff.

**Tell me about your family.**

I have three children and a lovely wife. The children are twenty-three, twenty-one, and seventeen. I am blessed beyond belief.

**What two things would you recommend to someone who is looking to take their marketing to the next level?**

Define whom you really want to work with. Do you want to work with a couponer, or do you want to work with upscale people who have expendable income, are easier to work with, and for whom money is secondary in the game? I've found that after it's all said and done I'm going to take the same amount of pictures and I'm going to do the same amount of hours, so I might as well do it with people who can afford more—and there's much more profit involved there. You've got to go for the profit level that gets you the quality of life that we've talked about. And, dealing with coupons is going to eat you up. I mean, that's what the department stores are for. They're for the couponers. You're for the higher-end clients who want to have a little bit more expendable income and who appreciate what we do.

**What is your hook?**

It's the image that I've created. The hook nowadays is that the name has been created, it's just living up to it daily. I've been very successful in integrating the systems necessary to live up to the image.

**Would you call it a designer brand?**

It absolutely is. It's just all about quality service and

> *"The phone doesn't ring unless you've asked for business."*

a creative look. It's all based on very good photography, by the way. Everything I have is truly first of all based on good photography and then from that point on its good customer service. Then it's good marketing to keep them coming. The marketing is first, but you have to have a good, quality brand. You can market until you're blue in the face, but if you can't take good pictures, that ain't going to work. It's all got to be congruent.

**What has been the most successful marketing philosophy, concept, or campaign that you've ever had in the years that you've been in the industry?**
A country club promotion where we go to the country club and offer them good, high-end executive portraits of their leaders. We initially photograph the board and the president and then invite the other members to call Redford Photography. We often have family portraits created at this location or at our studio and, with a digital imaging program like Photoshop, we put their names on the bottom of an 8x10-inch print. We put that print into an Art Leather 700 S album, and on the front cover of the album it says *The Golf Club at Nevelwood* (or whatever country club we're working with). We buy the cover, we buy all the photographs and the inserts, and we do the photography of the presidents and all the board members and all that. At the same time, that country club is constantly turning me on to other business because of the complimentary service I provide to the club.

My point is, it's a very, very good networking idea. It drives as many families to try your studio as you think you could possibly handle each year. Now we're working with two country clubs, and I'm a little scared that it's almost too much. The first country club we did has 600 members, and we did eighty members the first year, and now I've got two of those. I mean, I don't know if I can handle all the business they can throw at me.

Quite frankly, like I said, I can control how much work I do, which is a really nice benefit of being an efficient marketer.

**How many shooters do you have?**
Four. I photograph children and families. I have another gentleman who does all the high school seniors and the weddings. My wife does the children and families with me, and then my other son does the high school seniors that the other gentleman can't.

**You don't photograph any seniors yourself?**
No. Only in emergencies. I'll do twenty or thirty a year. We do about 600 to 650 seniors. I'll do twenty or thirty of those simply because my photographers are sick or out of the studio. Of the 650 seniors, you're going to have ten or twenty who need special treatment. I'm totally capable of doing it, but I don't wish to do it. I'd rather use the time on the boat!

> "That country club is constantly turning me on to other business. . ."

**When you're not working, where do you go for fun?**
The Caribbean, or Aspen, Colorado.

**What's your favorite food?**
I know, it's beef stroganoff, but I haven't had it in years. I was just thinking to myself, how come I haven't had it? Because it makes you fat! That's why.

**Favorite movie?**
*Dumb and Dumber*

**Are you serious?**
I really, really like Jim Carrey.

**Book?**

Any biography of a successful person. I literally have a hundred of them. I read only realism. I don't read many novels—everything I read is about people like like Sam Walton—anyone that's been totally successful, I want to know why.

**Is there an experience that you've had that just stands head and shoulders above everything else?**

I think working with a billionaire. I have a friend who's a billionaire, truly one of the world's richest men. I get to work with him all the time, I'm his photographer. I'm around Jerry Seinfeld and people like that, because he is . . . well, he's a billionaire, so he has private parties with people like Jerry Seinfeld, George Carlin, Bill Cosby, Jeff Foxworthy—I mean the biggest of the big. I

recently met Robin Williams! These people are brought in for private parties of fifty to sixty people, and I get to rub elbows and take pictures of these people, and it's just really really fun stuff!

**Who are your biggest inspirations?**

I've got to say Jesus Christ because I am a Christian, and I truly believe that he is the strength. Walt Disney for sure. Sam Walton, Ted Turner, people like that. These are people who just came from nothing and worked to have everything through their sheer understanding of capitalism, of trading services, and the sheer understanding of looking through all the red tape, seeing exactly what needed to be done, and doing it.

> "I get to rub elbows and take pictures of these people . . ."

# 2.
# DEVELOPING YOUR MARKETING STRATEGY

Before you can develop a marketing plan, you have to know what it is you want out of life—and I don't just mean setting goals for your business, but striking a balance between the energy you devote to your business and the time that you take for yourself. What is it you want out of your life personally? Time with your family, time to travel, or for your gardening, reading, or other hobbies and passions you may have? Be specific: Do you hope to spend more time listening to some really good music, watching old movies, wetting a fishing line, taking in an art show, reading the funny pages, or golfing?

● **TAKING IT ALL IN STRIDE**

To achieve balance between your professional and personal life, you've got to take your job seriously but take yourself lightly. It's called having a sense of humor! And having a sense of humor is not something that we are born with. It is a set of developed skills that allows us to keep flexible in the face of stress and change—and it really has nothing to do

with telling jokes, even though most people associate having a good sense of humor with just that.

Do you think you can tell a good joke? More than likely, you don't. Actually, only about 2 percent of the population can remember punchlines and tell a good joke.

On the other hand, do you feel you have a good sense of humor? There are people in this wonderful world of ours who go through life with a case of terminal professionalism. You know the type: "If I'm going to be successful, I must be hard-driving, hard-headed, and serious. I don't have time to laugh and play around. Leave me alone; I'm having a really good bad day!"

Those are the kind of people who end up with nervous breakdowns, end up dead, or worse yet end up old, bitter, cantankerous photographers! We need to smile and laugh at the simple things in life: a newborn baby, a sunny day, a home run in the bottom of the ninth, a great drive off the tee!

Having a sense of humor won't solve any of the world's problems, but it sure makes it easier to get

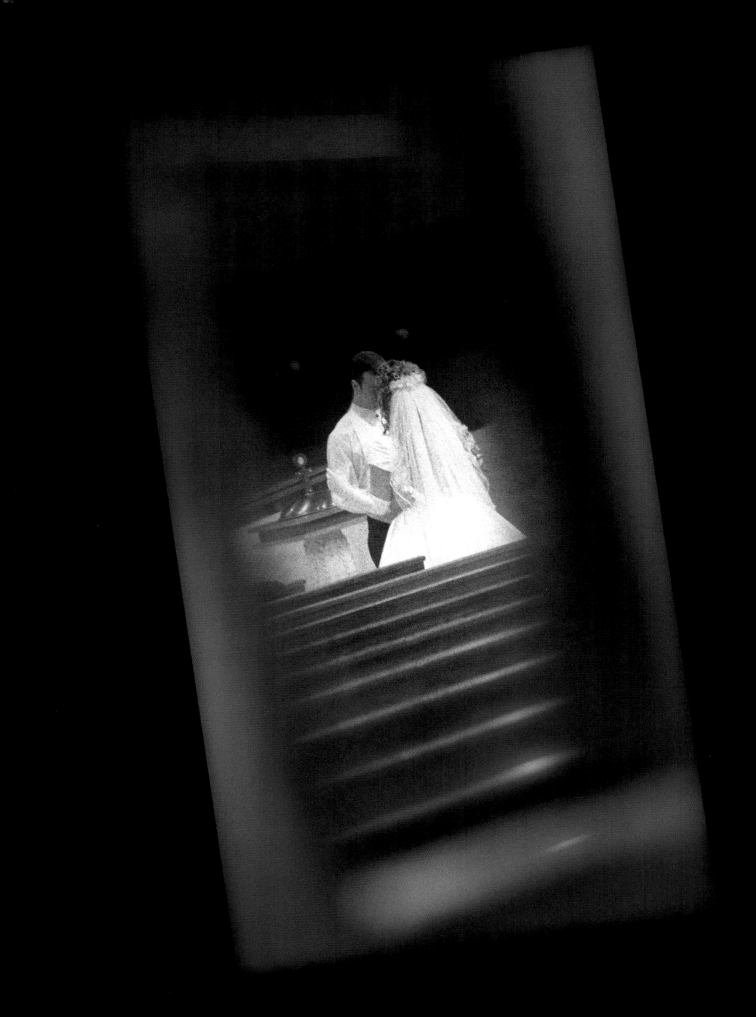

through those tough days that pop up every now and then. Such an outlook has the magical ability to sustain life. When people are on their deathbeds, they don't say they wished they owned more toys or had more money. They say things like, "I wished I would have worked less and played more."

Part of the reason we find it difficult to keep it light sometimes is the world we live in is full of stress! Stress isn't something new to mankind; our world is in a constant state of change, which is what causes stress. The vast majority of what we know about the world today has been learned in the last twenty years. In the past ten years, there have been 500,000 new commercials on TV and 10,000 new shopping malls. The Internet as we know it has sprung into existence, and the wonderful world of digital photography has come into being. No wonder we have such a difficult time keeping it light in the face of such radical changes in our world. But you know what? Life is a matter of perspective, and our thoughts can keep us healthy or can make us ill. It's all up to us.

Being successful has nothing to do with how much money you make, how many weddings you shoot, or how many sessions you photograph. It's all about proper balance in your life, or what I call perspective. We all need to be reminded from time to time that life is short, fragile, and precious. We need to remember that the job of photographer is only a job. Success is a constantly evolving journey, not merely a destination. You set your sights on the future to map out your goals in your personal life, just as you do for your business with a good marketing plan.

**FACING PAGE**—A top-notch marketer is constantly adjusting their techniques to maximum their potential.

> Success is a constantly evolving journey, not merely a destination.

You must have a vision of where you want to go. After all, we drive with our focus in the distance, not on the highway as it passes beneath us. Remember *Alice in Wonderland?* When Alice was walking through Wonderland, she came to a fork in the road and met the Cheshire cat. She asked, "Which road do I take?" and the Cheshire cat said, "Well, where do you want to go?" Alice responded, "I don't know," and the Cheshire cat said, "Then any road will get you there."

When I was in seventh grade, I had a childhood business that I ran out of my garage. If you needed a bicycle chain or seat or tire, chances were I had it! If I didn't, I would trade with the guy down the street to get one. At the time I didn't really understand any of the dynamics of marketing, but I sure seemed to have a lot of kids coming over!

Saturday mornings were the best; all of the neighborhood kids would ride their bikes up and down the street and would stop in to see what the "hot special" was for the day. The best deal I ever made was trading a set of blue handle grips for a dollar and a 45 record. I remember playing that record until the grooves wore out!

I used to take bicycle chains and horns to school to show my friends and classmates. Mondays were always good because a lot of kids received their allowance over the weekend. Sometimes I would get a special order for a banana seat or a sissy bar and would have to trade with someone else to be able to fill the order. In junior high there were a lot of guys who had so-called bike businesses, so I usually found the requested item.

There definitely wasn't much money to be made, but looking back, I learned an important marketing principal: In order to be successful with any business, you need to understand your potential customers

and then develop a strategic plan that attracts them to you. This is probably the most basic definition for the word *marketing*.

In the real world of business, things are a bit more difficult than they were when I was a kid, but the rules are the same. Before you can develop a marketing strategy, you need to follow certain steps.

First, realize that understanding who you are is essential to developing a successful marketing plan. The self-test you took earlier likely resulted in some self-discovery. Having an intimate understanding of what makes you tick is not only important to your business, but it is important in your life! Knowing your strengths and weaknesses, as well as what challenges and excites you, will help you to be the best you can be.

This is where quiet time comes in, because we all get into the 9-to-5 mentality and can become mere *observers* of our businesses. This outlook taxes your energy level, and it doesn't allow you to focus on the real issue, which is how to make your business more profitable. Nor does it free your mind to allow the expansive thinking that separates "good" from "great."

Let's compare your studio to a car with a full tank of gas. At the beginning of a trip you feel pretty good driving down the road and looking at all the sites. You're excited and enthused about your journey and not too concerned with what lies down the road. As the miles go by, the needle starts to drop on your fuel guage, and you start thinking about filling up. But the next gas station isn't for another hundred miles, so you continue driving. If you don't get gas soon, you will end up stranded on the side of the road! Now, would you let your gas tank get so low you run the risk of running it dry in the middle of nowhere? Likely not. So why would you allow your business to run for long periods of time without adding fuel to its tank?

The fuel for your business comes in the form of your creative juices and mental energy. No one has as much desire to make your studio succeed as you do. The challenge is in figuring out a way to look at your business from an outsider's point of view. What we would like people to think of us, and what they actually *do* think of us, are often vastly different. We may have the best intentions, but for whatever reasons the message doesn't come across the way we intended. We all probably have a few stories to tell.

> Knowing your strengths and weaknesses, will help you to be the best you can be.

**Brainstorming.** I have a couple of friends who were in the photography business for over twenty years. They had become weary after all those years of keeping their noses to the grindstone, and they decided to close down their studio and go to work for someone else. After a while, they realized that working for someone else was not their cup of tea, and they reopened their studio. But before they did, they had plenty of opportunity to research new and different ways of photographing, selling, packaging, and just about everything related to running their businesses. This actually began to become quite enjoyable for them, and before long, they had developed a head of steam that has allowed them to totally and completely reinvent the way their studio operates. What a joy it has been to watch as their new studio has grown from the bottom up all over again, and as they have discovered new and exciting ways of conducting their business. It's almost like they are going into business for the very first time, and it's because they allowed themselves the creative freedom to brainstorm for a breakthrough!

Is this something that sounds intriguing to you? Do you have the desire to reinvent your business and

replenish your creative juices? Brainstorming will give you the opportunity!

The most valuable asset you can have as a Power Marketer is an objective perspective of your business. In a sense, you need to put your entire business on a table in front of you, then stand on a chair and look down upon it. Here is a simple test you can take to help identify some objective details about your business. Grab a pen and paper and grade yourself on a scale of 1 to 10 (1 being totally unacceptable, 10 being perfect). Are you ready?

1. I am totally satisfied with my staff and feel they are doing the best they can do.
2. I feel my staff is happy and content with their jobs.
3. I feel I have a good understanding of my customer base.
4. I am satisfied with my current suppliers and know I am getting the best possible service, quality, and price.
5. I believe my studio front, gallery, and portrait park (or any other studio area that is visible to clients) are the best they can be.
6. I am satisfied with my current level of sales and profit.
7. I have a thorough understanding of my competition and know their strengths and weaknesses.
8. I feel the products and services I offer are complete, my prices fair, and my profit margins acceptable.

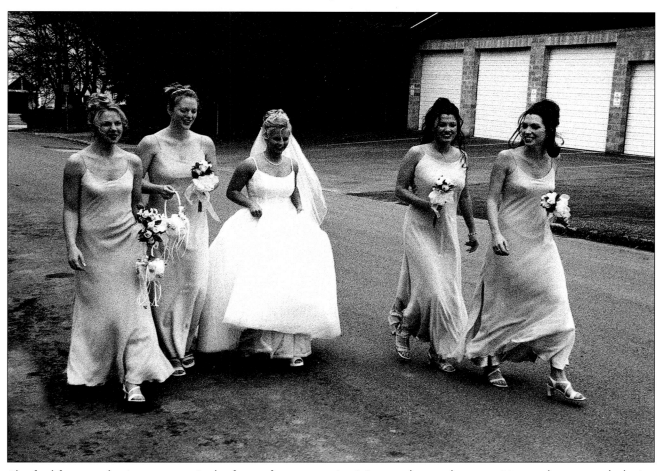

The fuel for your business comes in the form of your creative juices and mental energy. No one has as much desire to make your studio succeed as you do.

9. I am confident that my ordering procedures and inventory levels are under control.

10. I am aware of my strengths and weaknesses and can list them on paper.

Now, let's see how you did. Add up the ten individual scores to see how you stack up!

**90–100**—Great job! You obviously are in touch with the pulse of your business!

**80–89**—You have a pretty good understanding of your business, but realize there is room for improvement!

**70–79**—Things are becoming overwhelming to you, and you are searching for answers.

**60–69**—Your business is getting out of control and you are probably considering joining a monastery!

**59 and below**—You are wondering why in the world you got into this industry in the first place!

Remember, there are no pass or fail marks, only a better understanding or your business. We need to have a starting point, and now you know where yours is! If you scored lower than you had hoped, don't get discouraged! This just means you have more opportunities for growth and profitability!

### ● MAKING PROGRESS

Now that you have a fair idea of your business's strengths and weaknesses, it's time to look at some of the areas in which your business can be improved, no matter your score on the previous quiz.

**Understanding Your Customers.** We all know that our customers are, without a doubt, our most

> The most valuable asset you can have is an objective perspective of your business.

important assets. Whether you are just getting started in the photography industry and have a small customer base or have worked to develop one that is extremely large, it is vital that you understand everything you can about them. The value of this information will be obvious when you sit down to plan your first power-marketing campaign.

There is a small coffee shop located in a local town that is owner operated, enjoys a rather lucrative business, and offers a wide variety of coffees, fresh bakery items, and a pleasant atmosphere. For many years it has been the cool place to go and hang out. It is constantly packed with patrons. There must be at least ten more coffee shops within a six- or seven-block radius, but this lady's is the best.

One day several years ago I asked the owner what it was that lured the customers into her establishment. She said, "I bet I can tell you the first name and favorite drink of 99 percent of them. I want each person to feel they are my most important customer. Everything I do is with them in mind."

Isn't that a wonderful message? No wonder people come from miles around to sit and visit. She makes them feel like gold. Unfortunately, not everyone has the pizzazz and memory this woman has, but I bet each of us could do a better job of taking care of and listening to our valued customers.

**Measuring the Competition.** Throughout history, wars have been won and lost by many nations and many types of people. Some wars were fought because of differences in religious beliefs; others fought over territorial dispute; and still others because of the overinflated egos of their leaders. Regardless of the reasons why people fight wars, it's a given that the winner was well aware of their opponent's strengths and weaknesses and was able

to adapt their battle plan in order to effectively compete.

One of the biggest fears of any businessperson is the fear of competition, and in the photography industry, it is everywhere! Whether you realize it or not, competition is vital to the success of your business. It requires you to constantly analyze, adjust, and adapt your own business to a changing market. Those who react the most effectively are the ones who end up on top, while those who don't react at all end up in a different industry!

On the flip side, we are all charged with the responsibility to both introduce consumers to and educate them about our industry. In this respect, you are on the same team with every other photographer in your local area, state, and the country. But that's

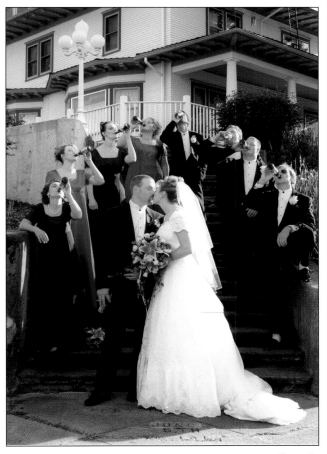

Other photographers do fun and creative stuff with their clients, but I'm the only one in my market who makes it a point to use those images in my marketing.

where the friendly competition ends. Beyond that, the consumer is the battlefield, and the name of the game is survival of the fittest. You are in business to generate net profits and provide for your lifestyle choices, just like your competitors.

If I were to ask you to list three strengths and weaknesses of your biggest competitor, would you be able to? Most of us are acutely aware of our strengths but won't admit any glaring weakness. That's human nature. In business, however, you must be able to identify the good and bad in your own enterprise, and in others' endeavors as well.

One of the easiest ways to learn about your competition is to go and visit them. Just sit down and have a cup of coffee with them, visit their studios or, better yet, make friends with them! No rule says that you can't get along with other photographers in your area. Invite some of them to your studio and maybe even exchange some helpful ideas on how to make your respective businesses better. Remember that we are all on the same team, and it is important to help each other. You don't have to give away any trade secrets—nor do they—but you may find that you can help each other out in many ways.

The goal in marketing is not to have your competitors fail, but rather to increase your chances of succeeding. If you ask most people, they will tell you marketing is a battle of products and services. In the long run, they figure, the best product will win. *Not true!* The only things that exist in the world of marketing are perceptions in the minds of consumers. Perception *is* reality. Everything else is illusion. What the customer perceives as fact *is* indeed fact.

**Identifying Your Hook.** So, what is it that you do in your business better than anyone else? What makes you stand out from the crowd and gives the customer a reason to come to you instead of the guy down the block? What is it about your studio that is so compelling that people can't help but want to do business with you? Do you know what it is? Or are you having a little difficulty identifying it?

In the world of marketing, we refer to this message that we send to potential clients as a "hook," and it is probably one of the most important assets your business has. Great empires have been built on great messages! If you don't know what yours is, you'll need to grab a pen and paper and spend some quiet time thinking about it. It is important to mention that not everyone can have the same strengths and be best in all categories, but to maximize your position in the market, you should be tops in at least one. Which one? Well, that is up to you to decide!

Once a customer has made up their mind about something, it is nearly impossible to make them believe otherwise. If one of your biggest competitors has spent lots of time, energy, and money to promote their Super Saturday Seventies Portraits, they probably own that category in the consumer's mind. You need to create a category for which you are known as the best.

In my studio, the slogan is:

*Graf Creative Group*

*. . . elegance, simplicity, sophistication*
*. . . with a little KICK!*

Everything I want a prospective client to know about who I am is wrapped up in a tidy package called a slogan. It communicates the fact that we do very nice, artistic work, but that we do it with a little something extra—some style, some attitude, some pizzazz! This is the message that I want to communicate to my clients about the way I do business, so everything we do from a marketing standpoint reinforces this message.

Several years ago, I had a wedding client who suggested to me that we get a photo of all the groomsmen jumping off a forty-foot cliff into Lake Coeur d'Alene in Northern Idaho. Well, in North Idaho in June, the water temperature is still pretty chilly, but being the kind of guy I am, I whole-heartedly supported the idea! After the wedding was over and the reception was in full swing, the entire wedding party and about half of the guests got into their cars and headed down to the lake. One of the only people who wasn't allowed to come with us was the groom. By this time, he was a husband, and he wasn't allowed to go play with the boys. His wife told him he needed to stay at the reception so he could meet the rest of her family, who had traveled many miles to come to the wedding.

Well, as we got to the location of the jump, the word had spread quickly that we were doing something spectacular with a bunch of groomsmen, so people from all over the shoreline peppered the side of the mountain to watch the event. Of course, there I was with my tuxedo, tripod, and Mamiya in hand, balancing myself on the side of this cliff with a little help from my assistant. After several minutes of

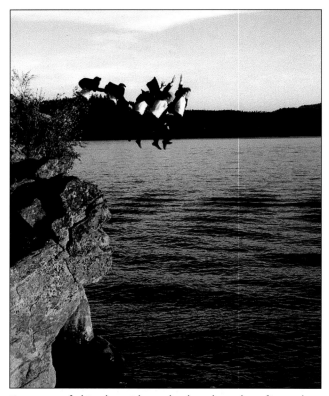

Because of this shot, I have had no less than five other wedding parties "take the plunge." People will call and say, "Aren't you the photographer who takes crazy shots like people jumping off of cliffs?"

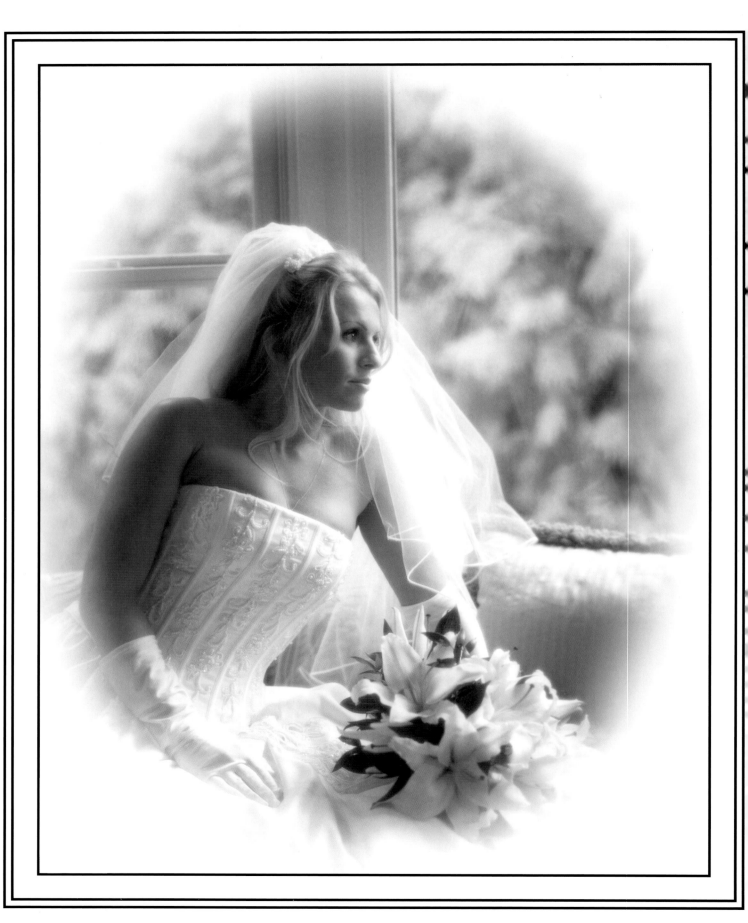

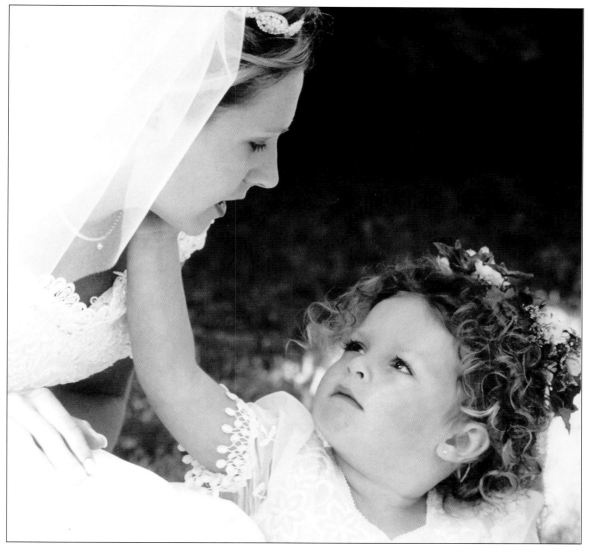

FACING PAGE AND ABOVE—Successful studios have several things in common: a well-trained staff; a solid customer base; a marketing strategy that generates excitement, lures new customers, and keeps them coming back; and something that separates them from the rest of the pack.

coaching each of the six groomsmen as to where to jump—and who was to jump in what order—so we didn't have a major accident on our hands, I loudly counted to three, and away they went!

Needless to say, the jump went off without a hitch, and to this day I use that photograph in many of my promotional pieces. (Believe it or not, the bridesmaids jumped off the same cliff, but the dresses over their heads didn't make for as good a shot.) Because of that single shot, I have had no less than five other wedding parties "take the plunge" off various cliffs

and bridges around the pacific northwest. People will call and say, "Aren't you the photographer who takes crazy shots like people jumping off of cliffs?" And of course I say, "Yep, that's me!"

For some reason, people think I am the only photographer who can take a photo of people jumping off of things. And they are willing to pay more for that. I don't have the heart to tell them that any photographer could do it. They think, if you want something crazy and spontaneous, call Graf Creative Group! Remember our slogan: ". . . elegance, sim-

plicity, sophistication . . . with a little KICK!" You can bet I will ride that marketing wave as long as I can.

Now, most wedding parties don't want to jump off a cliff—or anything else, for that matter—but that single image says to my prospective clients that I am willing to have some fun and try something out of the ordinary. This is just the type of client I want, and it's the exact type of client I attract!

I know that most other photographers do fun and creative stuff with their clients all the time, but I am the only one in my market who makes it a point to use those types of images consistently in all of my marketing efforts. We still spend most of our time doing the traditional portraits of mom, dad, grandma, and grandpa looking into the camera smiling, because that's what they buy, but the shots that get us hired in the first place are the fun, crazy, and spontaneous ones. I spend at least ten minutes during each wedding doing off-centered, nontraditional, fun images for my bride and groom. That's what they expect when they hire me, and that's what my studio delivers. So one of the positions or marketing niches that we have developed in our market is the "fun and crazy" position.

Do you have a slogan for your studio? Can you summarize your marketing message and what position you occupy in one sentence (or less)? Creating an effective slogan isn't rocket science, but it does require some of that brainstorming I spoke of earlier. It may require some quiet time, a pen, a notepad, and a good cup of coffee!

At the bottom of the page is little exercise that will show you the incredible power of a good slogan. See if you can identify the companies behind each one.

Your slogan doesn't have to be complicated, but it should communicate who you are and what you want your market to know about you. The same is true of your logo. It can be something as simple as your selection of a font, or something with extensive graphics and colors. But whatever it is, it should appeal to the specific demographic you want to attract.

Make sure you are consistent with everything you do, and make an investment in your business cards, your stationary, your signage—anything that projects who you are. Sometimes you need to spend a little money to make a great first impression.

While successful people may not be the very best at what they do, they use top-notch marketing to position themselves in the mind of the consumer as better than the next guy. When you go to a grocery store, do you always buy the best product, or do you choose the one that is most cleverly marketed?

| SLOGANS | COMPANIES |
|---|---|
| 1. Just do it. | A. Wonderbra |
| 2. We try harder. | B. Avis |
| 3. Nothing runs like a Deere. | C. Sharp Electronics |
| 4. From Sharp minds come sharp products. | D. John Deere |
| 5. You're in good hands. | E. Domino's Pizza |
| 6. Have it your way. | F. Allstate Insurance |
| 7. We care about the shape you're in. | G. Nike |
| 8. Fresh, hot pizza, delivered in 30 minutes or less . . . guaranteed! | H. Burger King |

*Answers 1–G; 2–B; 3–D; 4–C; 5–F; 6–H; 7–A; 8–E.*

The bottom line is that the biggest hook you can offer your clients is yourself. All of the fancy equipment, wonderful sets, and expensive lighting won't get you very far if you don't have the personality to sell yourself.

If you look at successful studios around the country, they tend to have several things in common: a staff that is well trained and motivated; a solid customer base; a top-notch image; a creative marketing strategy that generates excitement, lures new customers, and keeps them coming back; and something that separates them from the rest of the pack. Again, we call this a hook, and it is vital that you have a firm grasp on what yours is. Some examples of a hook are:

- A special black & white technique that you offer your wedding clients
- A popular kids' portrait club that you have been running for several years
- A portrait park that allows families and other clients to be photographed right on the premises
- A special lighting combination you use in your camera room

- Hours of operation unique to your studio (e.g., Saturday/Sunday sessions, evening sessions, holiday availability, etc.)
- Your willingness to go to a location of your client's choice
- The friendliness of your staff
- Your location (whether it be in town or in a country setting)
- Specialization in children, families, seniors, weddings, pets, etc.
- The fact that you photograph weddings with two photographers instead of one

These are only a small handful of possible ideas, and there are literally hundreds more. But when it comes right down to it, the client is drawn by your perspective, personality, sense of artistic interpretation, and/or sense of humor. The client is hiring *you*, regardless of the style of photographs or albums you

People are buying emotion when they purchase photography, and there isn't a lot of common sense that goes into it. If they have fun and enjoy their images, they'll tell their friends. (Photo by Bill Winter.)

sell. The bottom line is that the biggest hook you can offer your clients is yourself. All of the fancy equipment, wonderful sets, and expensive lighting won't get you very far if you don't have the personality to sell yourself. If you can establish a personal connection with your client, price becomes secondary, because they are investing in *you*.

Following this logic, people who recognize they don't have the personality of a salesperson will be well served to hire someone who does. Many photographers are incredible at creating stunning images for their clients and win all sort of awards from their peers for their technical and artistic expertise, but without the ability to sell themselves or promote their businesses, failure is not far behind. Long gone are the days when you could hang out a shingle and

people would flock to you simply because you were good. In today's fiercely competitive field of professional photography, only the strong will survive!

Again, you are selling yourself and your personality and the experience you give people who come into your studio. If they have a positive and pleasant experience and enjoy their time with you, there is great value in that, and they will tell their friends, their neighbors, and their families. They will talk highly of you because they enjoyed themselves, not to mention that your talent will show in the images. People are buying emotion when they purchase photography, and there isn't a lot of common sense that goes into it.

An important factor in determining what it is you do better than anyone else is to make sure someone

else doesn't already make that claim. One of the basic rules of marketing is that it's better to be first in your own category than to be second in someone else's. You need to find an area that nobody has taken as their own, and then build on it.

I once knew a business owner who had the "me too" syndrome. He always waited to see what everyone else was doing and then he would do the same thing. *Big mistake!* Over time, customers became aware he was always copying other people's ideas, and he continued to lose business until he had no choice but to get out of the industry. If he would have focused on his uniqueness, he would still be around today!

I'm going to ask you some questions about category ownership, and I want you to think of the answers:

- What is the top computer company? Which company comes in second place?
- What is the top rental car company? Who's in second place?
- What is the top-selling copy machine? Which manufacturer is in second place?
- What is the top-selling facial tissue? Which is the next best-selling brand?
- What are the two top-selling soft drinks? Name the product in third place.
- Who is the number-one manufacturer of jeans? Which brand is in second place?

While you may have figured out that IBM, Hertz, Xerox, Kleenex, Pepsi and Coke, and Levi's hold the top spots in each respective category, you may have run into trouble recalling the names of the runners-up. Are you starting to get the idea? Nobody cares about or even remembers the guy who comes in second place! I hope you are getting those creative juices flowing and realizing what makes you special and unique to your marketplace.

Regardless of your abilities as a photographer, if you don't have the ability to sell yourself or promote your businesses, failure won't be far behind.

One of the basic rules of marketing is that it's better to be first in your own category than to be second in someone else's. You need to find an area that nobody has taken as their own, and then build on it.

**Establishing Program Goals and Objectives.** John Wooden, the great coach for the UCLA Bruins, used to sit down before each season and write down a list of goals for himself, then for each player, and for the team. Periodically during the season he would pull them out and reread them. No other coach in the history of college basketball had as much success as John Wooden, and it wasn't by chance! His ability to set goals, maximize his resources, adjust his methodology as the season progressed, and follow through until the end, produced championship after championship, year after year!

Athletics teaches us a lot about setting goals and working toward them with diligence. Your business requires the same level of commitment in order to achieve your objectives. In marketing, your goals should be based on three considerations:

- Are the goals realistic and attainable?
- Does the program help you achieve your ultimate goals and objectives?
- Will the results be measurable and trackable?

If you can answer yes to all three questions, then your program has the potential to be successful! It may be worth investigating your idea further!

Now, let's take another little break to hear from two more of our marketing power-corner experts—Don MacGregor and Bambi Cantrell.

## FOCUS ON . . .
## DON MACGREGOR

Perhaps one of the most passionate and gentle men I have ever met, Don MacGregor gives new meaning to the term "image marketing." I was fortunate to be able to spend some time interviewing him at his photography school on Vancouver Island, British Columbia, and came away revived and filled with a new sense of what my business could become. His total dedication to his craft is one of the main reasons why he has become one of the most successful marketers in all of Canada, and his insights are extremely valuable and informative.

MacGregor Studios, a Vancouver-based studio for almost thirty years, specializes in portrait and wedding photography. Don's creative wedding albums and family portraits have been displayed throughout Canada and the U.S. and are included in the permanent collections of the Canadian and American Professional Photographers Association archives as well as the International Exposition of Photography at Epcot Center.

Don teaches across North America and is well known for his passionate programs. This is a man who absolutely loves photography!

For more on Don's educational materials and workshops, visit www.macgregorstudios.com.

**Mitche: In your opinion, what is the biggest challenge that faces our industry now and in the future?**

*Don:* The digital revolution's obviously the key part of the biggest change. Everybody's jumping on board. Everybody who's an amateur is jumping on board. I think that Kodak and Fuji are also driving the digital change. With innovative products and software, anybody can get into digital photography. Our biggest challenge within that overview is for us, as professionals, to set ourselves apart and fall back on the traditional foundation of skills. You've got to really know your lighting, composition, and elegant or very free-flowing posing and be able to put it together exceptionally well.

If amateurs who want to rise to the top become really strong photographers and are successful financially and artistically, we are going to have to become better photographers. We can no longer rely on the fact that it's some mystical kind of thing, because everybody and everybody's brother is going to have the same cameras that we have. We go to weddings now and somebody comes up with a D10! So we've got to become better photographers. A lot of people will almost have to relearn the craft. As wonderful as digital is, it's got some great things we can add into our tool collection, so to speak. But shooting digitally today requires a lot of stronger skills in exposure, for example. It takes a great deal more time. It's a lot more expensive.

**What percentage of your clients purchase wall portraits?**

100 percent! If we don't sell a 30-inch or larger family portrait, it's because the client is not presold or properly prequalified before they come to place their order. Preselling, for me, is helping clients by making their purchasing decisions easier. Sales are not created in a sales room. Sales are created in a mall when

you first talk to the client. We do our very best to create a portrait they will want to display as a wall portrait. With a lot of our wall portraits, we do the consultations in the homes. We do the sales in the homes as well. I try to do all the projections right in the client's home. You're helping them put a piece of art on their wall.

**Describe your marketing philosophy.**
There's a conference that I went to many years ago, and I learned a saying: "Is the price too high or the purchasing desire not high enough?" I don't think there are any more powerful words in our business than those words. Is the price too high or the purchasing desire not high enough? So, my marketing philosophy is to do whatever I can to create a strong purchasing desire. Utilizing emotional symbolism, in other words, putting something into those images that has a special meaning, is the way to do it.

**How many mall displays do you have at any given time?**
We probably do anywhere from six to ten a year. They're fairly expensive. Up in Vancouver, Canada, it runs about $1,600 a week for us to do a mall display, so that's a fairly big chunk of change. The other thing that we've gotten involved in over the past couple of years is linking ourselves to activities that have the right kind of client. An auction to benefit the arts or the heart or stroke foundation, or breast cancer organizations—any kind of an auction—is good for business. Not a silent auction. I'm not a real believer in that. I want a verbal auction. I choose auctions where people are spending serious amounts of money—where bidding $1,000 is nothing. You want your photography to be perceived as a

*"Is the price too high or the purchasing desire not high enough?"*

very valuable product, so you have to get it out into these markets to see a real benefit.

**What do you feel are the most important attributes of a Power Marketer?**
I would say one of the key things is discipline—having a yearly outline, and then a monthly outline, and then a weekly outline. Then the discipline that goes with it. So, the Power Marketer in our industry would be somebody who is very disciplined and has a very structured plan that they are going to accomplish. And that usually requires somebody dedicated to do it.

**Do you feel that Power Marketers are born, or can you learn to become a savvy marketer?**
Yes, you can. I think you can learn to become a great marketer, but it's going to take some passion. The problem with many people in our business is that all they want to do is take pictures. They don't want to collect sales. It's something really simple that you can do.

**How do you balance the passion for your photography and the necessity of having to be efficient with your business and your marketing?**
I return to that issue on discipline. That's the way I do it. This is what I need to have done, and I try really hard to delegate other things as well. Even within my marketing activities, I'm starting to learn how to delegate, to say "This is what I expect out of you." This is what I want you to do." Because I'm doing all the planning, I'm laying out the game plan for this project that we want to do. I can say, "This is what I want you doing so I can really concentrate on getting the time to market." We have

one of those dry erase boards in the studio, and when we have a project, I mark it down on the wall. I give one project to each of my employees, Don, Carol, Dave, and so forth, and say, "When the project is complete, erase it." It's interesting to see somebody who's got three projects up there, while the others have completed and erased theirs. The person who is lagging behind is going to try to catch up. It's a competitive atmosphere, but it makes us more efficient.

**What are the most important things to you in life, not so much photography but in your life?**

I'm a person who is driven by goals and challenges. I just have to have a challenge to do it. Obviously things like family are important to anybody. I also love my dogs!

**What kind do you have?**

Two shelties. I love my dogs passionately. For a lot of people, children are important, but I don't have any of my own, so it doesn't have the same importance to me that is does for people with children.

**What do you do when you're not working? What do you do to relax?**

I love fishing, hiking, and camping. I love getting out in the mountains and just checking out all the places that are left to only me. At one point several years ago, I was losing my joy in my photography. I had forgotten the reason why I got into the business, which is that I love taking photographs. One day I picked up a travel magazine and I saw these people on kayaks and killer whales and I thought, man, that looks like fun! I want to do this! So in 1991, I organized a trip and I took eight people along! I rented kayaks, a boat, and all this kind of razzle-dazzle, and

I just had fun taking photographs. That trip rekindled my passion!

> ## "The jack-of-all-trades is a thing of the past."

**What would you recommend to somebody, young or old, who is looking to raise the bar on their marketing efforts?**

One of the key things is going to be to identify the type of photography they want to do. The jack-of-all-trades is a thing of the past. You've got to have a game plan! Some of us get a little arrogant and think, "I'm a *real* photographer, I'm a *Master* Photographer, I am an *artist*." Well, I take photographs and I sell them. There's no "we are artists." There are a lot of guys who want to be the artist because they don't channel their efforts toward the people who can afford to buy profitable items, and then there are some people who want to make a good living. It's just the volume of work. That would be the first key thing. You make a decision of where you want to take your business. What type of branding do you want to have for your business? Do you want to have a caricature-like branding, or do you want to have a general studio branding that you make photographs for a very reasonable price?

Once you've made that decision, then you start to build that game plan, and you do it with realistic goals like divide-and-conquer principles. Most photographers fail with their project because they look at the whole big project. All they ever see is the whole project and they just don't get anywhere. If you beak down that big project into step one, step two, and step three, it becomes more manageable—divide and conquer. You've got to think, "I'm only going to look at step one right now and then soon enough, step two." Then tear it up!

**What is your hook? What is it that makes you unique and different in your marketing?**

Our environmental work and our canvas wall portraits. There are so many calls that we get because we built an identity for our studio with these products. I built a powerful identity around wall portraits and environmental work.

**Can you think of one marketing campaign that you have done that has been the most successful for you, that you continue to utilize?**

Mall displays. Actually, any kind of displays, malls, home shows. However, while the home shows are good, you get a lot of people who go to them just looking for a good deal. But if you get into a mall—a higher profile mall that has some pretty good stores—it can work pretty well. I want a mall that has expensive clothing stores. I want that type of high-quality store that's frequented by people who are real nice to talk to. To make it work, you've got to make your display a very good one. You've got to put good dollars into that display. So many people try to do displays on the cheap, and they pay a very dear price!

**All it takes is five seconds to make that impression. There's no second chance to make a first impression. That is so vital. It all depends on the type of market you want to attract.**
Even the clothing you wear, how you physically present yourself is important. Yes, a lot of us wear jeans or khaki slacks sometimes—but I don't wear jeans to the studio. I will wear khaki slacks, but they look nice, and I dress well. It creates that image, that package, that perception.

**Have you done something that was just an absolute bomb?**

"You've got to put good dollars into that display."

Yes! Our newspaper ads. With my goals and prices, I'm expecting a four-figure purchase for every family session. That's not something you just pick up, like a pair of shoes. You've got to have a need for them. It's hard to create emotion with an ad in a newspaper. It was a waste of money for us. Also, our yellow pages ads—but there's a lot of controversy in that. I still think they're good in a lot of ways. People that do need to find us can find us. But for our kind of business, the newspapers have not worked. If I had a high-volume business, there's no question that I'd be in the yellow pages and in the papers a lot. If a photographer wants to reach clients who will invest a couple hundred dollars on their portraits, then newspaper ads could work.

**What's your favorite food?**
Italian!

**Favorite movie?**
*Boy Scout.*

**Book?**
Anything by Wilbur Smith: *The Sparrow Falls, The Falcon Flies,* the Courtney series.

**What are they about?**
Very early years of laying the groundwork of white civilization in South Africa. It goes way back in time. These books are great reading, and you get lost in them. Like the newest one called *Blue Horizon*— it's great. It's very thick and you don't put it down!

**Like Harry Potter?**
It's so much better, and an awful lot of Wilbur Smith books are based on actual history with some interest-

ing characters that are part of his main plot. I would love to go to Africa, just because of the words that this man uses as he describes those lands and the mountains.

### What was the best experience in your life?

Probably when I've been out camping and hiking. I've got very fond memories of that. Actually, there's one memory in particular. My good friend Mike and I took off to a place called Flores Island—just the two of us and his dog. We built a campfire and decided to take a walk down the beach. When we arrived at the beach, we suddenly realized that we were going to get a fantastic sunset! We looked back out to where our cameras were and thought we'll never make it there and back again and so the two of us walked over, hiked up on these rocks, watched the tide come in, and watched the sunset for at least an hour. No cameras, no words. It was just a wonderful environment, very natural with the air clean and fresh.

### Who are your biggest inspirations?

It would have to be photography people, because that's been my whole life ever since I was young. I photographed my first wedding when I was still in grade twelve.

> "I photographed my first wedding when I was still in grade twelve."

### Are you serious? Did you go to school for it?

The first two years of my wedding photography career, my grandmother used to drive me to my weddings because I was not able to get my license.

Frank Cricchio is a strong influence in my career; Al Silver is, too. Paul Skipworth has had a tremendous affect on my life. The man is very smart and disciplined. He is also an incredibly fine photographer. He is one of those who are a step above in terms of the marketing, and he is so excited about his marketing! He wants to have great photographs that elevate him up above the rest.

I think for us and for a lot of other photographers, it makes sense to have a passion for building emotional symbolism in our photographs. It makes it a lot easier to sell them! It relates back to the theory that if you're priced higher, there will be a bigger demand for your services. Emotional symbolism actually is an incredibly powerful sales tool. You educate the client about the value of the image that you're making as it relates to their emotional return. "Mrs. Jones, you know, this portrait is going to give you such enjoyment. Every time you look at it you're going to remember, and you will get goose bumps." I'm actually selling clients on the value of that emotional symbolism, and it has worked extremely well!

## FOCUS ON . . .
## BAMBI CANTRELL

Bambi was my first mentor and teacher when I was just breaking into the industry. She sees the big picture much better than most people, and her insights on how brides think has broken new ground. An acclaimed wedding photographer and teacher, she has been on the faculty of Hasselblad University and the Winona International School of Photography. Her cutting-edge images have appeared in *Martha Stewart Living, Professional Photographer, American Photo, Time,* and *Ebony*—just to name a few. She is one of the country's most sought-after workshop instructors, and her creative energies seem to have no end! For more information on Bambi Cantrell's programs and studio, visit. www.cantrellportraits.com.

**Mitche: In your opinion, what is the biggest challenge that faces our industry now and in the future?**

*Bambi:* I think there are a number of challenges. Sure, the economy is not very good and obviously that is a major challenge for all studios. But, I think, equally as challenging is the struggle that photographers are going to have with the transition between technology and feeling pressure to go digital, and thinking that's the answer. In reality, there are as many headaches with digital as there are with film, if not more.

You have to be prepared for the workflow. You have to be prepared for the enormous amount of work that goes into it.

**They forget that time has a cost.**

Right. I think that's a very key point. Photographers don't appreciate the value of their time. We are generally just folks who would do this for nothing because we love what we do—we're very passionate about our craft, and we don't tend to appreciate the value of our time.

**I love that! If you can, describe in a nutshell what your marketing philosophy is.**

I do not allow myself to become the purse police. In other words, I don't allow myself to prejudge a person's ability to pay a healthy sum for my services, and I don't look at them and assume, well, nobody in my town would be able to afford this or that because no one has ever charged that before. It's like saying that only a rich person buys a Mercedes or a BMW, when in reality there are a lot of people from blue-collar neighborhoods who buy things like that. Though they are really beyond their means, they do it because it makes them feel good and they want to buy it. We wouldn't have a national debt in the United States if people shopped within their means. So, first, it's not

judging people and basing my pricing upon what I assume that they can afford to pay.

**How can you go about playing purse police? Is there a step one-two-three that you actually go through with your marketing to achieve this?**

Yes there is. I can tell you exactly what I do. I study fashion magazines like a guru. I study them very thoroughly to see how people who are successful at marketing handle marketing. And then I absolutely copy their concepts—not what they're doing, but I copy their concepts and philosophies. These people spend millions of dollars trying to attract my client, so rather than look at other photographers, I study how other businesses do it. To me, we make the biggest mistake by being little lemmings who just copy one another's pricing.

So, I prefer to tailor my marketing after successful companies like Calvin Klein, Armani, and Gucci—those that are successful at making their products become a designer label. People who are successful like that have very good advertising agencies that work for them, and so I copy their concept. I try to create a product that is very unique looking, and then I am very careful not to underprice it. That's the worst thing you can do. There's a firm and absolute truth in our world and that is, you're only as good as what you charge. And it's about perception and about the perceived value of a product, not its actual value. We all pay the same amount of money for the basic paper that our work is printed on, but not everyone creates a Bambi Cantrell or a Joe Bussink. It's what's on that paper that counts.

**Here's a follow-up question to what you said about perceived value: do you have certain things**

> *"These photographers ask, What can I do that's different, where can I go next?"*

that you can recommend to someone who is either (a) getting into the industry for the first time, or (b) they've been in it for so long, they've gotten complacent with their promotions and their marketing and forget that perceived value and real value are not necessarily the same?

Yes! They need to go shopping. That sounds very simplistic but they need to go shopping and they need to study. They are not going for the entertainment value; they're going to study how successful companies are continuing to market their products. It's not only about marketing, but it's also never getting complacent and doing the same thing over and over again. I hear photographers all the time say things like, "Well, if it isn't broke, I'm not fixing it." Photography is not a profession that does not change. I got married in 1975, and when I got married, the double exposure was the rage. Well, if you do that technique today, would you be real popular in the photo industry? Of course not. I must say, however, that a lot of that double imagery, a lot of the digital stuff that we're seeing right now, is very similar to the double exposures of the 1970s.

**What are the most important attributes of a Power Marketer? Is it a photographer's ability to separate themselves from the rest of the pack and do things so uniquely different that nobody could compare or compete with them?**

I think that's basically it. It's the photographers who do not allow themselves to become complacent and continue to do things the same way, but who, every single week and every single day are always striving. These photographers ask, What can I do that's different, where can I go next? And they're giving them-

selves lots of visual imagery to help them to grow. I go back to fashion magazines. Everything I've ever learned about photography, I've learned from fashion magazines. There, things aren't always technically correct, but when it comes to being successful, you can't focus just on what is technically correct. Besides, brides do not know what a technically perfect photograph looks like—the only thing they understand is impact. Impact is absolutely everything. And so my Power Marketing stems from the standpoint that I never allow myself to become complacent and always, every single day, I'm pushing myself. I ask myself, What can I do differently, how can I grow, where are the trends at not only now, but where are they leading me? This way, my photography can be on the cutting edge every single day, and I can continue to do new things and reinvent myself. You have to reinvent yourself. And that is especially important as the economy gets worse or the economy is in a bad slump like it is. Everybody and their brother has a camera now. So, you must continue to reinvent yourself if you want to keep your uniqueness and be able to continue to be one of those people who are sought after, even in difficult times.

**Do you think Power Marketers are born, or can they be self-taught?**
I think there are some people who are born marketers, but I don't think that it's something you can't learn. I think you *can* learn it. But what you have to do is to develop a plan, and you have to continue to strive for that. You can't just try something one time and go, "Okay, it didn't work" and then go lay down and do the same thing you've always done. You have to have a particular plan. You have to lock yourself up in your office for two days and say, *this is really*

> ## "Lock yourself up in your office for two days and say, *this is really important.*"

*important.* I know a lot of mediocre photographers who are outrageously good at marketing; they do a fantastic job of that and are very successful. And I know, on the other side of the coin, some of the world's top photographers are starving to death because they do not know how to sell their products and they give themselves away.

**What's most important to you in life, and how does your marketing come into play with those things?**
Everything centers around my family. I believe that photography is not my religion, it's only my profession. And I truly believe that I want to be successful in my profession so that I can pursue the more important things in my life, which are religion, my family—things that have more lasting value. Photography is a real nice thing, and I am very grateful that that's what I love to do, but it is not like it's the absolute Holy Grail. It's not what life's all about. That's probably one of the most difficult things—that balancing of one's spirituality with their career and then keeping balance with your family and your goals as a family. It is a constant battle, but one of the rules of my household is always that we always have at least one meal together every day, and we have dinner together literally every day except for on the weekends. It's tough when you have a kid who's eighteen and wants to have their own life. But we try to make it a special point of having meals together every single day, and we don't allow business things to get in the way of the more important things in life. Another thing that I've done too is that I give myself permission to take time off. I think that's one of the problems with small business owners—we tend to work all the time.

I'm in my office every day at 6:00 a.m., but I make a point of taking a weekend off every month,

even in the busy season. Even if I've got tons of weddings in the summertime, once I have three weekends booked, I take the fourth weekend off. That way I have a weekend off that I can spend with my family and have a normal life. So many times we tend to just work, work, work, work, work for six months, and then we crash and burn and our family doesn't see us for six months. Well, about two years ago the little lightbulb finally went on in my head, and I said to myself, "You know what? You're not going to starve to death if you just do three weekends a month. Raise your rates a little bit and then do three weekends." It's worked out really well. So, now I have a weekend off next month. I'm going on vacation with my family at a normal time of the year, and so that's what we do.

**What two things could you recommend to somebody either getting into the business or someone who's been doing it for a long time and wants to take their marketing to the next level?**
Here's what I would do. Step one: I would go to your local shopping mall or your local Barnes and Noble, and I would buy all the top fashion magazines. Step two: I would go through those magazines and I would pick out the ads that stand out. They can be really outrageously shocking, and that's a good thing too. There's a wedding gown designer by the name of Reem Acra who for years had this wonderful ad of this bride wearing red—bright red—eye shadow. It was very shocking! Like any of our real brides in the entire world would probably wear red eye shadow. But the point was is that it was so outrageous that it was like, "Wow!" You had to stop and look at the ad.

That's the whole point in advertising, to get people to stop and look at your stuff. Find out what the

common denominator is between all the ads, and adapt that to what you're doing. Take notes and say, okay, what did they do to get me to notice this ad? What does it look like? Step three: Create some photographs that have the same feel and are outrageously different from what you usually do.

**And it doesn't matter what kind of photography you do, right?**
Right. It can be portraits, weddings, any style. This is not about weddings. This is about portraiture in general. Today's high school seniors are so fashionable it's not even funny. Calvin Klein to me is top dog, number one—absolutely!—because they have found a way to make men's underwear so completely interesting that men will spend $18.00 for a stupid pair of underwear! $18.00 for a pair of underwear! Look at its box, look what comes in it.

**What is your hook? What separates you from the rest of the pack?**
I've become a designer label. That's what my hook is. I am a designer label in Northern California.

**So, over the years you have branded yourself as a designer label?**
Absolutely! I have branded myself. My hook is the fact that I have all of the elements that a designer label has.

"Take notes and say, okay, what did they do to get me to notice this ad?"

**What are those elements?**
I start with a unique product, an interesting product. Not a perfect product by PPA standards, but a product that is very interesting. And that product changes every season. It changes weekly, monthly. It continues to adapt. The second thing that I've done is I've quit being the purse police, and I've decided that you're only as good as what you charge—so I charge

a very healthy premium price for my product. Because if you look at Calvin Klein and Armani and Gucci—and people buy those stupid little purses with the ducks on them!—what separates those from the cheap products is the fact that they've found a way to make their products look unique and people feel secure buying that product because they are paying more for it. We just opened a Tiffany's in our town, in Walnut Creek where my studio is, and I'm thinking a Tiffany's store? Why in the world would they have one here in Walnut Creek, California when there's all kinds of jewelry stores that sell for much less?

Well, it's because some people prefer to spend more money at certain occasions, like a wedding. That's a very fancy occasion. It's like the one time in their life that they're going to splurge and not go cheap and buy some little cubic zirconia ring. If we only buy within our means, then, you know, people that are only buying cubic zirconias, they would not buy diamonds because it would be so impractical. And we have to quit thinking like logical beings.

When it comes to the wedding arena and pricing, we have to think illogically because it's the one time that logic does not reign as king. They're not buying a carton of eggs from us. They're buying a piece of artwork. They're buying something that's a very unique product that they can't get anywhere else. And when it comes to a wedding, I have found that the more expensive I've become, the more sought after I've become because it's like, "Well, I want the very best for my wedding. I should hire Bambi because she's very expensive, but she's also very good." You get what you pay for, which constantly comes to the floor on the wedding day.

"It's the one time that logic does not reign as king."

**Now, with the designer label that you've created, how do you go about communicating that to your customers?**

I make sure that if I'm going to be a designer label that I'm going to do advertising like a designer label does. In other words, my ad in a magazine is going to be very striking. It's going to be captivating. I'm going to do images that are very unique and very exciting. Not the typical picture of a bride standing at the altar. They're never going to see a typical advertisement featuring the normal picture that everybody has in their studios. You would never see that from me. Because I don't want them to believe that what I do is like everyone else's work, because that gives them a reason to go price shop.

**Which marketing campaign or promotion has been the most successful and most productive for you?**

I have a very specific type of approach to my wedding business and my portrait business where I do advertise, but it's very soft sell. I'm not one who's going to go out and do tons and tons of advertising. I'm not after large numbers, I'm after quality—the very elegant, high-end type of client. So what I basically do then is make sure that the promotional literature that is going to go out to a bride is very unique, that it's beautiful and that it's not like anything that they've ever seen.

**Has there been anything that you've done either from a campaign standpoint or just from an image creation standpoint that has just failed miserably?**

I can tell you exactly what failed miserably. It's when I tried to be the cheapest guy in town! I'm not kidding you. When I started as a photographer on my

own about fifteen years ago, I decided that I would be the cheapest photographer in town, and I'd generate so much business that people couldn't stand it and they had to come in to see me, and they'd hire me. I'd be so busy that I'd beat everybody else to death, right? Well, I was the cheapest photographer in town, and I just about starved to death that first year because people kept thinking, well, if you're that cheap, then you really must be horrible.

**When you're not working, what do you do for fun?**
I really like taking pictures for myself.

**When you go on vacation, do you take your camera?**

"Well, if you're that cheap, then you really must be horrible."

Yeah, I take my camera when I go on vacation. My favorite vacation though is spending time with my son, and I go scuba diving. But other than that, when I'm on vacation I like to lay and become a little beach potato and read. I want to read everything on the bestseller list. I want to do absolutely nothing. It's going to be a chore for me to get up and go walk on the beach!

**So, when you're not working you want to hang out with your family and plan quality activities with your family?**

Yeah!

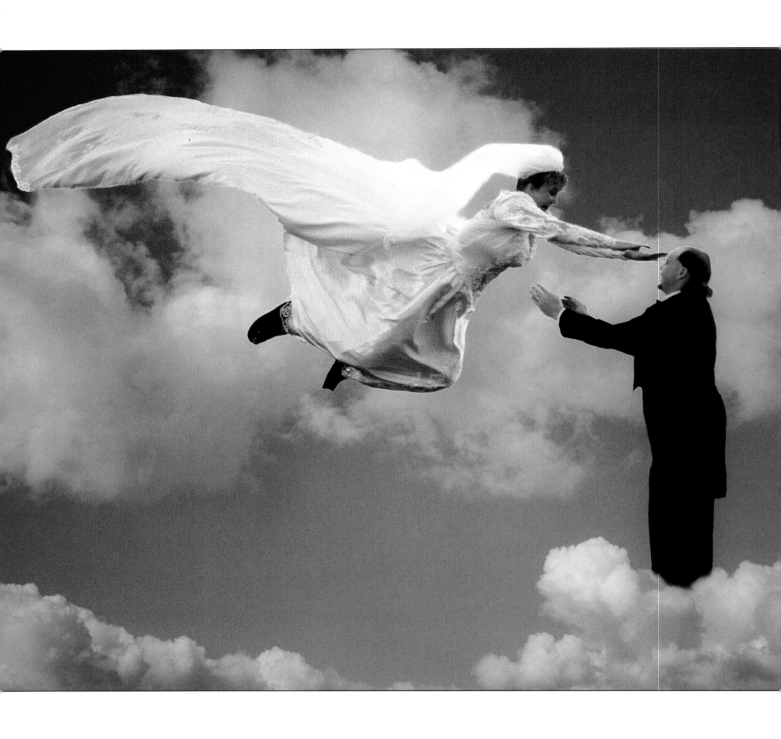

# 3.
# POSITIONING
# FOR PROFIT

Do you ever find yourself saying, "It seems there are far too many ways for me to market and position my studio. How can I know what's best?"

Photographers do have many opportunities to reach out to prospective clients. The list below should give you some idea of the variety.

*What* does the word *positioning* mean to you? To me it's a very simple concept: it means putting yourself in front of the exact customers you want, with precisely the message you want to communicate, at just the right time. The best part about being an entrepreneur is that you can decide all of these things on your own.

Revitalizing and reenergizing your marketing plan—or as I like to call it, your battle plan—is not an easy task. We began the brainstorming process with the Power Marketing self-test. We also talked about being able to identify what it is about your business that is unique and special, what it is that separates you

## WAYS TO REACH PROSPECTIVE CLIENTS

| | | | | |
|---|---|---|---|---|
| price lists | business fairs | welcome wagons | refrigerator magnets | frequent-user photo clubs |
| brochures | county fairs | hospital promos | pencils | promotional raffles |
| flyers | yellow pages | mall displays | pens | newsletters |
| business cards | chamber directories | restaurant displays | bumper stickers | telemarketing campaigns |
| direct mail | radio ads | library displays | calendars | press releases |
| signage | TV commercials | bank displays | newspaper ads | art shows |
| billboards | airplane banners | beauty shop displays | magazine ads | window displays |
| auto lettering | hot-air balloons | referral programs | merchant co-ops | sample albums |
| table tents | websites | vendor programs | slide shows | . . . and more |
| bookmarks | Internet banner ads | key chains | video shows | |
| bridal fairs | search engine listings | coffee mugs | charity events | |
| senior fairs | gift certificates | notepads | church directories | |

Long gone are the days when a portrait or wedding photographer could hang out a shingle and expect people would flock to the door simply because he or she was a good photographer. In today's fiercely competitive field of professional photography, only the strong will survive!

from everyone else in your market. We call this a hook, and I trust you now know what yours is.

When you are in an area where several competitors are going after the very same dollars you are, you must have something that separates you from the rest of the pack and makes you stand out. Either you are unique and different, or you are out of business! It's that simple! Having a me-too approach will not get you very far down the road to being a successful Power Marketer. The old saying "the guy at the top of the mountain didn't fall there—there's a reason why he's there" holds true.

The ultimate compliment we can get as photographers is, "Boy, what a great experience we had having our portraits done! You made it fun, easy, and very relaxing. We all had a wonderful time. It may have cost a little more than going somewhere else,

but it was worth it!" If your clients are made to feel special during the time they spend with you, they will undoubtedly become more emotionally attached to their portraits, which in turn means that they will spend more money on them. The bottom line is to make a profit so you are around to answer your phone when they call to schedule another session.

There is absolutely nothing wrong with making a profit; in fact, without it, you have no business! You shouldn't feel guilty about getting paid well for what you do; it allows you to support your family, take vacations, and accomplish the things in life that mean the most to you, and makes it possible for you to sustain your business so that you can provide the same service when your customer calls back to schedule another session! There is no reason to feel guilty about getting paid well for what you do.

The lesson in this whole thing is that if your clients have a positive experience with you, from the first time you answer the phone to when they pick up their portraits, they will become your best salespeople and will make many referrals to your studio.

## ● FINDING YOUR NICHE

Before you can decide on the exact position you want to occupy in your market, you have to know what you want out of your life. In chapter 1, we talked about setting goals, both personal and professional, and how important it is to achieve a proper balance between your work and personal life. Now, if you are the type of person who needs to work seven days a week, from sunup to sundown, then your goals might be altogether different from those of

someone who works hard when it's time to work, but wants to spend time doing the things in life that are important to them. What is it you need in your life to make you feel fulfilled, complete, and satisfied?

Whether it's time with your family, time on the lake, or time at the office, you need to have a firm grip on what your priorities are. I also spent quite a bit of time talking with you about having passion—passion for your work, for loved ones, and for living! Without passion, life becomes one big blur, and we go from day to day without any real direction or conviction.

I have a friend who is a wonderful photographer and a very hard worker. He loves to shoot weddings—so much, in fact, that he shoots two, three, sometimes four weddings in a single weekend. And

If your clients have a positive experience with you, from the first time you answer the phone to when they pick up their portraits, they will become your best salespeople and will make many referrals to your studio.

In both life and photography, you need to know where you want to be and what your priorities are. (Photo by Steve Mackley.)

not just during the prime season. Even in the so-called off-season, he always seems to have at least a couple of weddings booked every Saturday and Sunday. If you were to sit down and have a discussion with him, you would find out it is part of his overall battle plan to shoot that many weddings, and it definitely gives him a rush of adrenaline after he has finished a grand-slam weekend.

Now, if I were to shoot four weddings in two days, not only would I be practically useless to the last bride and groom, I would also be a lump of burned-out flesh come Monday morning. We all have a place and position to fill in the marketplace; he understands what his is and is very good at what he does.

If your goal for your studio is to photograph four to five hundred weddings a year, then you will need to position your business accordingly, carefully selecting everything from the vendors you build a referral network with, to the pricing of your packages. On the other hand, if you only want to cater to the elite and photograph ten to fifteen upper-end weddings a year, your approach will be altogether different. Either way is perfectly fine, you just need to know where you want to be and what your priorities are.

# 4.
# THE TEN CATEGORIES OF POWER MARKETING

If I collected 8x10-inch photographs from everyone reading this book and spread them on the floor in a row, then asked a customer to come and choose the best, they would really have a hard time making a selection. The fact is, all would be very good—and many would look alike. Photographs are like most other products on the market: they are very similar; it's only the packaging and positioning that differs. We all claim to provide fantastic quality, but it's clients who judge the caliber of your work and customer service *after* they've experienced the way you do business. To lure and keep your clients, therefore, you must appeal to them by positioning your studio based on something beyond mere quality.

The overall goal is to somehow create value for yourself, your products, and your services so you can charge more, make more, and have more time off to do the things you enjoy in life. There are literally hundreds of things you can do to promote your business, but when you break it down, there are only ten categories of Power Marketing. A description of each follows.

## ● 1. LITERATURE

This category contains your business cards, price lists, direct mail pieces, handouts, statements, letterhead, envelopes, box stuffers, flyers, brochures—and anything else that is printed with your name on it.

When a potential client first lays eyes on or touches your business card or portrait package flyer, he or she will immediately form an opinion regarding the quality. How does it look? How does it feel? What would you think if someone were to hand you your business card? Do you use paper stock you find in the clearance bin at the local paper supply store, or do you use a high-quality designer stock? Remember that everything the client sees, touches, smells, observes, or feels goes into determining what they will be willing to pay for your products and services. It's okay to use the half-priced discontinued stock *if* you're not aiming for an upscale reputation.

We will further examine the role that your literature plays in creating a positive image in a later chapter, but for now you need to be aware of how vital that first exposure to you actually is.

I know of a photographer who ordered 10,000 full-color direct mail pieces to send to prospective customers who lived within his target market. He had recently moved to the area and wanted to introduce his studio to the neighborhood. He offered a free, all-you-can-eat pizza feast, complete with breadsticks and soft drinks at his open house. He had a great portrait special, an offer they couldn't refuse, and a deadline of the following week to call to schedule an appointment. He had all the right ingredients for success.

This photographer purchased an expensive list that gave him only the best-qualified leads for his business. The folks on the list made at least X dollars per year, had X number kids, shopped at X stores, and drove X cars—all the right stuff! He hired a local mail-room company to address and stamp each piece, then he prepared his staff for what was sure to be a gigantic influx of phone calls and walk-ins on the day the piece was to hit residents' mailboxes.

The day finally came—and went—without so much as a single phone call. He waited and waited and waited. Four days went by before the first call came in, and the person said, "Is this the studio that's having the free pizza party and the family portrait specials? If so, I would like to schedule a session to take advantage of your special offer. But I've got to tell you, it sure was difficult to get a hold of you! Your name, address, and phone number weren't listed in your mailing."

Despite the fact that he had put in all of that time and effort—not to mention money—he had forgotten to add his name, phone number, and address—a very expensive mistake! Simple rule #212 is: *Always have someone else proofread any marketing materials a client will see.* This can prevent a lot of simple-to-correct mistakes!

> Everything about your studio sends a message to prospective clients.

Believe it or not, I had a photographer come up to me after a seminar a couple of years ago who was ready to throw in the towel just because he wasn't getting much business, and the business he was getting wasn't willing to pay very much for his photography. Well, by looking at the hardware around his neck, it was obvious to me he wasn't lacking in photographic expertise or respect from his peers. In fact, he'd received lots of awards and lots of medals. When he handed me his price list and business card, it was immediately apparent what the problem was: his card was printed on thin paper stock with faded black ink, and his photocopied price list had black streaks running through the middle of the page. My first impression? I wouldn't want to invest any time or money with him if I were a customer, regardless of how great a photographer he was.

Ask yourself whether the quality of your literature reflects the market position you want to occupy. If not, change it *today!*

### ● 2. CURB APPEAL

Everything about the appearance of your studio—from the signage outside to the general appearance of your studio sends a message to prospective clients. The interior of your studio sends a clear message, too: the lighting on your gallery prints, the way the phone is answered, the smell that hits you when you walk in the front door of your gallery, and even the cleanliness of your restrooms all impact your position in the market. Are you projecting the proper image for the position you want to own?

### ● 3. THE WORLD WIDE WEB

By now, most photographers have established some sort of presence on the Internet—either through a

website or at the very least through an e-mail account. With digital photography and online proofing taking our industry by storm, there is no reason why you should *not* be on the web.

Developing a website is a very cost-effective way to introduce yourself to prospective clients, both near and far, to showcase your work, and to outline your session fees and package prices. If you don't have the know-how to build a website, take a class and start with a simple, one-page site that features your contact information and other basic facts about your studio.

Aside from marketing, the Internet is also a powerful sales tool. You can now create a personal website for each of your wedding and portrait clients so that Grandma in Florida and Uncle Bob in California can view and purchase your work right from the comfort of their homes! For instance, when we are finished photographing a wedding, we hand clients a small website announcement card with a private password they can use to view all of the images from the day. When the bride and groom's website goes online a few weeks later, we get a tremendous number of visitors. And guess who many of those guests are? They are next year's clients. They have seen us in person and have gotten to know a little about our style and creativity. They have also viewed our work online, so when they do call the studio, they are calling only to find out if we are available to photograph their wedding.

New referrals are also directed to our website, which, again, immediately familiarizes them with our work. We give these prospective clients a password and allow them to browse through a wide variety of images. This allows them to get to know us at their convenience without having to schedule an initial sit-down visit. After viewing the images, a face-to-face meeting is scheduled—but only once mutual interest has been generated. Again, our Internet

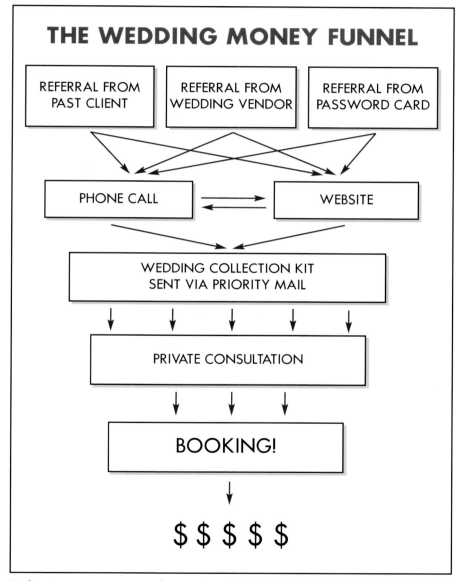

By having a systematic and easy-to-understand lead-generation program, you will guarantee that you will have a steady flow of quality leads into your studio. The above chart details the way we accomplish this.

presence saves us a lot of time. If we aren't what the client is looking for, they find out before they make the trek to our studio, and it saves us from investing time and energy in someone that may or may not be right for us.

Without the Internet, our marketing plan would be very different than it is today. Because of our ability to post wedding and portrait images on the web and keep in touch with current and potential clients via e-mail, we have been able to tremendously enhance our marketing impact.

## ● 4. ADVERTISING

Advertising is the most expensive type of marketing. This category includes yellow pages ads, Val-Pak inserts, newspaper and magazine ads, mall display space, radio and TV commercials, and Little League banners. In essence, it's the type of outreach that you must pay someone to conduct on your behalf. Advertising is considered *passive* marketing, because it doesn't require you to become personally involved in the success or failure of the program.

You can easily get sucked into advertising in every form, but without careful monitoring you'll eat money faster than you can eat a pig at a pig roast. I prefer to have a Power Marketing approach, meaning I want to play an active role in the success or failures of my programs.

A word of caution: We all need to at least have a listing in the yellow pages so our clients can easily find us, but beware of the salesman who offers you the world on a platter! Regardless of the type of advertising you participate in, you must make sure it fits into your overall goals and objectives for your business and your life. Many businesses have disap-

How do people perceive your studio? Are you the intimate bistro where you would expect to spend $100 on a nice meal, or are you the drive through where $2.95 will get you the works?

peared due to overzealous advertising campaigns, so make sure you have your ducks in a row before jumping into expensive advertising. There are many fantastic books and tapes on the market that do a wonderful job of detailing how to develop your advertising.

## ● 5. PRICING

Once a potential customer believes something, it is virtually impossible to change their mind. Therefore, it is *very* important that you carefully consider where

you want to position yourself in terms of the price of your work. Yes, my photography is high-priced. Let me tell you why.

If you are known to be the lowest-priced photographer in your market, you will never be associated with high quality or great service. If you walked into a car dealership and saw a BMW for sale for the price of a Yugo or a Ford Escort, you would be suspicious. You'd probably think there must be something wrong with it in order for it to be priced so low. Of course, the opposite is true also—if a Volkswagen was for sale for the price of a Mercedes Benz, there wouldn't be many takers.

A couple of years ago, I had a riding lawn mower I decided to sell, so I took an ad out in the local paper asking $50. The mower had seen better days, but it still ran and would cut grass just fine. I just didn't want to be bothered with the hassle of trying to sell it. A week went by and I didn't get a single call. The second week went by, and still, nothing happened. By the third week, I began to realize what was taking place, and I raised the price up to $200. *Bam!* The calls came flooding in, and I got the asking price. At $50, people thought there must be something wrong with it, and so there were no takers.

When establishing your position in the market, you've got to decide what you are worth. More importantly, what do you want to be worth? When you work for yourself (like many of us do), you have both the joy and the anguish of deciding what you are worth to someone else, and need to figure out ways to communicate that worth to your potential clients. If you want to be known as the low guy on the totem pole (which I hope nobody out there does), you will never be known for offering the best quality or the best service.

We always expect to pay more for good quality and great service. When you go out for a nice meal complete with soft candlelight and romantic music playing, with a gourmet wine selection and hand-carved chocolate bunnies for dessert, you will pay a premium fee. We call this selling the sizzle with the steak! When you want something quick and easy without all the glitz and glamour, you will pay substantially less.

How do people perceive your studio? Are you the intimate bistro where you would expect to spend $100 on a nice meal, or are you the drive through where $2.95 will get you the works? More importantly, where do you want to be in the future? If you are priced too low, people will associate you with low quality, poor workmanship, and bad service. There will always be plenty of business at the bottom of the pile, but it comes with a very high price!

Clients don't pay us for the cost of our time or the cost of their portraits; they pay us for the value of our time and the value we bring to their life. If we show up ten minutes late for a consultation wearing flip-flops and a T-shirt, we show the client that we don't value ourselves very much, so why should we expect them to value us? If you want to be a Cadillac, then act like a Cadillac, dress like a Cadillac, and project an image like a Cadillac! (Or at least like the human equivalent!)

The compliments and referrals that stem from the work you produce for your clients validate your work. When there is a demand for your time, you can charge more for it. That said, you should note that you can build value for yourself by making it appear that you are busier than you really are. If your schedule is wide open, the customer will wonder why. If you make them wait, your value will rise, and so will your profits.

> If you are priced too low, people will associate you with low quality.

Your prices need to be based on what the market will bear, not only on your expenses. When a customer complains about price, you just haven't shown them enough value for the price you are asking. You should be proud of your prices! Remember, *too-low prices scare people away.* It's not that our clients won't pay our prices, but rather that we are afraid to charge what we are worth. I'm not saying you need to raise your prices through the roof tomorrow, but you do need to be acutely aware of your current position in the market, and you should have a well-defined course of action to achieve your goals for the future. If you want to position yourself differently down the road, start making changes *today* that will lead you down the road to success. Don't wait for another day to make the necessary changes to ensure a better tomorrow.

### ● 6. PRESS RELEASES

If *you* can get people talking about you, there is little need to *pay* someone to talk about you. All you need to do is tell the media something about you that might happen, will happen, or has already happened. Just let the media know that you've hired a new employee, that an existing employee received a promotion, that a part-timer is being promoted to full-time, that you'll be expanding your studio, presenting a new line of products, or will be hosting a holiday open house or a summer barbeque. You can also let them know when you are invited to speak at a trade association meeting or convention; win awards at your local, state, regional, national, or international competition; earn some sort of degree; or are publishing a book or an article in an industry magazine. These are all legitimate reasons to write a press release, and it costs you nothing! With press releases, all you need to generate a little interest is a piece of paper, a pen, a fax number, or an e-mail address! If you think that the same businesses are being mentioned time and time again in your local newspaper, you are probably right! Editors are constantly looking for any newsworthy item for the business section, and they love it when it comes to them in the morning fax!

If you want to be considered the expert, you have to look and sound like one. If nobody has appointed you the expert, appoint yourself! Blow your own horn! Your goal is to create an awareness of your business, which in turn will lead to an increased value for your products and services. If you can generate interest in your business by announcing all of the countless positive changes in your business, why not do it?

### ● 7. TIME

We are all on equal footing when it comes to time—we each have 24 hours in our day and 365 days in our year. And we can't buy more for any price. The only choice we have is how we spend our time. What kind of value do you put on your time? Are Saturdays and Sundays more valuable to you than weekdays? Are your evenings more valuable than your afternoons? I imagine most of you will say yes to these questions. If that's the case, why is it that we charge the same for our time on a Sunday morning or a Wednesday night as we do on Tuesday afternoon? It's perfectly okay to offer sessions on Sunday mornings or on a weeknight, but wouldn't it be nice if we could be compensated for giving up our most valuable personal time?

I used to shoot about 75 percent of my senior sessions after 5:00 p.m. during the week. I truly believed it just wasn't convenient for the kids to

**What kind of value do you put on your time?**

Your prices need to be based on what the market will bear, not only on your expenses. When a customer complains about price, you just haven't shown them enough value for the price you are asking.

make it in during the day; after all, these students worked, they had practice, and they had other appointments to keep. Not to mention the light in the evening was outstanding! After a while I noticed that some other studios were busy during the day and closed at 5:00 or 6:00p.m. I also began to realize that other professionals—doctors, dentists, etc.— were open only during business hours, and people managed to find time to visit them.

I found that some other studios offer sessions outside of regular business hours, but at a price—and then I instituted "prime time" pricing for these sessions but offered lower prices during regular business hours. It was amazing how many people magically found time for their sessions during my normal business hours. Yes, there were the people who still needed to have an evening session, but it was now their choice, and I was better compensated for my time.

I still shoot approximately 25 percent of my senior sessions after 5:00 p.m., but I can now justify spending that little bit of extra time away from my family because of our new pricing strategy. How much value do you put on your time? Would offering prime-time pricing help position your studio in a more favorable light? It's something to look into.

## ● 8. REFERRAL NETWORK

The referral network is your biggest ally. It's your most powerful marketing resource, and it can take your business to new levels. After all, referred clients spend more money, are generally happier, stay longer, and come to you already sold. Let's talk about the two types of referral networks that you can build in your business.

The first network is comprised of other professionals like tuxedo shops, children's clothing stores,

mens' and women's clothing stores, D.J. companies, caterers, civic groups (like the local chamber of commerce), florists, dental offices, doctors' offices, health clubs, entertainment centers, golf clubs, and so on. Not only can such businesses/professionals be an excellent source of referrals, but you can also partner with them in cross-promotions.

You may already have partnered with a strong group like this, or maybe you haven't invested much time or effort into developing this circle of peers. In either case, I challenge you to sit down with a pen and notepad and brainstorm until you come up with a list of other businesses you would like to develop a more substantial relationship with.

Now, while that's a topic deserving of a book in its own right, we should note here that there are some simple things you can do to get the ball rolling. First, you can mail some of these business owners an invitation to a special open house at your studio to talk about how you can all become part of a new referral network team. During this meeting, you can exchange information on each other's business so you become better educated about them, and they can gain knowledge about the many facets of your business, as well.

This kind of network is mutually beneficial, and it doesn't cost anything but some time to develop a constructive relationship with other companies that share your goals. You can also pick up the phone and give them a call, or go visit them at their place of business. I guarantee they are just as interested in cracking the marketing code as you are.

If you aren't already taking advantage of your clients' testimonies to earn referrals, you can begin today. Create a short questionnaire to give to your client once they have picked up their finished portraits.

We have relationships with several other vendors in our market area, and they consistently send prospective clients in our direction. These referred clients are already prequalified, meaning the other business has already done a sort of screening for us and, since they know the type of client we are looking for, and what our price ranges are, they only refer people who meet those standards. This fact alone makes my job much easier. When I answer the phone and the person on the other end says "I was talking to Mary at ABC Florist, and she showed me some of your work and your package information. I want to check to see if you are available for my wedding," I can breathe a sigh of relief. With these clients, I don't have to deal with the standard questions most people ask when they find your name in the phone book. Prequalified clients are ready to do business with me.

The second type of referral network, and by far the most neglected by photographers, is comprised of past and present clients. You probably have hundreds if not thousands of past clients in your database who know and trust you, have already purchased your work, and have had a pleasant experience with you. And what are you doing with those happy, satisfied customers? If you are like many photographers, not a whole lot! Their positive testimonies are largely untapped—but you could use them to draw new clients into the fold.

If you aren't already taking advantage of your clients' testimonies to earn referrals, you can begin today. Create a short questionnaire to give to your client once they have picked up their finished portraits. You can have them fill out the questionnaire while they are at your studio, or you can send it home with them to complete and mail back to you. Be sure that your questionnaire asks them to rate

*The entire sales and marketing game is built on creating a positive emotion.*

their total experience with your business—from their experience with your staff, to their satisfaction with the session, to their ordering process, and their impression of the final portraits. Try to stay away from questionnaires that let people check a box or write in a number from 1 to 10. You want to obtain as much information as possible from these clients, so ask them to write out their answers in descriptive terms. At the bottom of the questionnaire, you can ask them for the names, addresses, and phone numbers of friends or family members who might be interested in having their portraits created. If your clients are satisfied with their total experience, they will have no problem whatsoever with giving you these leads. And guess what you can do with those new names? You've got it! Send them a letter with an offer they can't refuse, or better yet, ask your client to write a letter to send to them.

Whatever you do, strike while the iron's hot! If you wait too long, the afterglow will diminish. The entire sales and marketing game is built on creating a positive emotion, and you will lose your momentum if you wait too long. The best marketers and salespeople understand this dynamic and develop the emotional trappings to guarantee a fantastic experience—and large sales averages.

If you want to reward clients who fill out a survey with complimentary gift wallets, a free sandwich and soft drink at the local sandwich shop, or a complimentary session, that's up to you. But do something to thank them for their time. If a customer says to you, "Boy, we sure had a great time with you and we just love or portraits," say, "Great! Can you put that in writing?" Testimonies are king. Make getting them your number one priority, then blow your horn and sing your praises to the entire world!

| NAME | DATE | STUDIO | P-BOOK | PAPER | FRIEND | FLORIST | CATERER | CHURCH | WEB | ASSC | TV | RADIO | OTHER | SESSION | ORDER |
|------|------|--------|--------|-------|--------|---------|---------|--------|-----|------|----|----|------|------|------|
|  |  |  |  |  |  |  |  |  |  |  |  |  |  |  |  |
|  |  |  |  |  |  |  |  |  |  |  |  |  |  |  |  |
|  |  |  |  |  |  |  |  |  |  |  |  |  |  |  |  |
|  |  |  |  |  |  |  |  |  |  |  |  |  |  |  |  |
|  |  |  |  |  |  |  |  |  |  |  |  |  |  |  |  |
|  |  |  |  |  |  |  |  |  |  |  |  |  |  |  |  |
|  |  |  |  |  |  |  |  |  |  |  |  |  |  |  |  |
|  |  |  |  |  |  |  |  |  |  |  |  |  |  |  |  |
|  |  |  |  |  |  |  |  |  |  |  |  |  |  |  |  |
|  |  |  |  |  |  |  |  |  |  |  |  |  |  |  |  |
|  |  |  |  |  |  |  |  |  |  |  |  |  |  |  |  |
|  |  |  |  |  |  |  |  |  |  |  |  |  |  |  |  |
|  |  |  |  |  |  |  |  |  |  |  |  |  |  |  |  |

TOTALS

It's easy to fall into the trap of writing checks every month for yellow pages ads, or newspaper ads, or costly mall display space. I spent $5,000 a few years ago on a great looking TV commercial that was flashy, trendy, and upbeat. I expected great things to happen as a result of having commercial exposure of that magnitude. Guess what? It was a big bomb! I received a grand total of one phone call. I could have spent that $5,000 to better generate revenues for my studio. But instead I spent it on a very expensive lesson.

There is absolutely no better marketing program in existence than to build a client base with referrals from past satisfied clients. If you can effectively use both types of referral programs to generate clients, you'll never need to spend money on expensive advertising again!

## ● 9. DATABASE/DIRECT-MAIL MARKETING
While the short-term goal of a marketing campaign is to get customers to come to you for the first time, the overall goal is to keep them coming back over and over again—and to get them to tell their friends and family about you.

You already have their names, phone numbers, and buying habits. They already know and trust you. That's what we call the perfect target market! If we can do a great job in nurturing and developing our past and present customers, there will be little need for expensive newspaper advertisements, bridal fairs,

FACING PAGE—When a new client calls or walks into your studio, ask them how they heard about you and record their response. This will show you which forms of marketing are working and which aren't. If you are spending $200 per month on a yellow pages ad and receive two calls a month, you can probably find a better use for your $200.

big yellow page ads, and the like. All your clients would come to you by way of other clients. Wouldn't that be nice?

## ● 10. PHONE
The goal of every effective marketing campaign is ultimately to make the phone ring, right? And if you can't book the session, all the marketing in the world is useless! Do you know how much it costs to make the phone ring?

If you already track each call that comes into your studio, this exercise will be easy for you. If you don't, you will need to track every call that comes in for a period of time—let's say one week or a month. (Of course, calls from your family, friends, and pizza delivery shop don't count!) When you've tallied your incoming calls, divide your total expenses by the number of calls you received. You might be surprised by the amount. I've heard of numbers as low as $3 and as high as $1,100. You can also take your total sales for a given period and divide it by the number of calls received during that same timeframe. This will give you the approximate dollar amount that each call generated. While it's not an exact science, the exercise will give you an idea of where you are. Are you happy with the results?

When your client reaches your voice mail or answering machine, what do they hear? The first thing you want to do is to listen to your message. This ought to be fun! If I surveyed a hundred studios around the country to determine what was on their answering machines, I'll bet that the average message would play out something like this:

*Hello, and thanks for calling. If you've reached this message during normal studio hours, we are either with a client, on the*

Do you know how much it costs to make the phone ring?

*other line, or on location. Please leave us your name and number, and we will give you a call back when we return. Thank you, and have a nice day.*

Does your message sound similar? Don't worry; its not just photographers who do that, it's all of America! Don't you think people get tired of listening to the same old thing every time they call a business? So why not add a little pizzazz to the mix? Have some enthusiasm, exhibit some sincerity, and have some excitement in your voice!

There are several things you should pay attention to when listening to your message. Does it sound far away and tinny? Is there enthusiasm in the voice, and is it sincere? Are the words spoken clearly and concisely, or do the words run together and sound rushed?

There is nothing worse than calling another business only to encounter a voice message in which the speaker sounds bored, irritated, and disgusted. It makes me not want to do business with them! Make sure that your own message is friendly, spirited, and welcoming! This is something you can do right now if you so choose! Grab a piece of scrap paper, write out your script, and put a new message on your machine.

The same rules apply when you answer the phone. You want to sound approachable, trustworthy, professional, and glad to be alive! A simple "Good morning. This is Eric Smith. How can I help you today?" is a good start. (Of course, a number of variations like "Happy holidays. This is Mary. How can I help you today?" work just as well.) If you use your first name, you are much more likely to have the caller give you their first name without having to ask for it! And once you have their first name, *use it!* People feel important and special when they hear their name, and it makes a

Why should clients pay more for your products and services? The key is in your perceived value.

conversation more personable. Ask questions and then shut up! The best way to show clients you value them is to listen. Hear them out; we were given two ears and one mouth for a reason.

Treat each call that comes into your studio like gold. These calls pay the bills and allow you to buy your new camera equipment. If you have a staff person who handles a majority of the incoming calls, make sure they fully understand that it's the studio's image on the line each and every time they pick up the receiver to say hello! The phone is our first opportunity to make a positive impression on potential clients, and there is no second chance to make a first impression.

We have so many choices when it comes to making a purchase. There are three grades of gasoline, six types of milk, ten different kinds of car batteries, three ticket prices for the ball game, and three different finishes on our portraits. Some people only buy the most expensive, and some people only buy the cheapest. The phone is a powerful tool in helping to make their choice much easier.

The key to good marketing is you must be heard! You want people to talk about you and be able to easily find you. Your goal is to first create awareness for yourself, then to create value.

Regardless of what you are selling, I guarantee there is someone else out there selling it cheaper, better, and faster. So why should clients pay more for your products and services? The key is in your per-

**When someone calls you and you answer the phone, you are marketing.**

ceived value. They need to think they will get more from you than the guy down the street. If you don't already believe in yourself and your ability, why would anyone else? This point is well illustrated in an often-told story about Pablo Picasso. As the story goes, the artist was sitting outside one day. A woman passing by asked if he would do a quick sketch of her likeness. When he was done, the lady asked how much she owed, and he said, "That will be $2,000 please." The lady said, "For twenty minutes of your time?" And he said, "No, for a lifetime of experience." If you have something great but don't have the means to let people know about it, you will fail. You cannot *not* market, just like you cannot *not* communicate. When someone calls you and you answer the phone, you are marketing. If someone calls and you don't answer the phone, you are still marketing. If your business card is wrinkled and stained, you are communicating a message. Positioning comes down to how others view you. Marketing is the way you shake hands, the way your voice sounds on the phone, how you look, and how you walk. It is as much style as it is substance. The best marketing plan costs you absolutely nothing!

Once again, let's check in with our marketing experts. Beginning on the next page, we'll hear from Charles Lewis—a successful photographer who has been teaching marketing to other photographers for many years . . .

## FOCUS ON . . .
## CHARLES LEWIS

This wonderful and generous man has been teaching photographers how to make top dollar with their photography for many years. Chuck is known for his powerful sales and marketing ideas and for making photography a super profitable profession. He has also created twenty-three video tapes and seventy-four audio tapes.

His passion for sharing with other photographers throughout the world has earned Chuck a reputation as one of our industry's marketing superstars.

Chuck had a great deal of good advice to offer, and this was another example of how a fifteen-minute interview can easily turn into ninety minutes!

For more information on Chuck's money-making ideas, e-mail him at cjlphotog@aol.com.

**Mitche: What do you see as being the biggest challenges facing our industry now and in the future?**

*Charles:* The number one challenge is digital. Digital is going to be the downfall of an enormous number of photographers because they're putting all of their time, money, and effort into trying to learn this new technology. I agree that digital is going to be the future of our photography, there's no question. But they're putting money they don't have into it and spending time that should be spent on marketing and selling. They're putting their resources into this digital thing, and if you can't sell an image on film, you're not going to be able to sell it when it's captured digitally. People are thinking, "Well, I've got to keep up with the times. I've got to keep up with my competitors. I've got to be able to use all this new technology—I'd better learn it." Well, they can't make it with film, and yet they're thinking digital is going to make it for them.

Digital is not a magic pill that's going to fix all their problems and help them meet their challenges. They should be spending their time on marketing and sales methods. How you present your photographs is the single most important decision of your entire career. It's more important than any other decision you will ever make. Who cares how you create the photographs? Who cares what f-stop and what equipment you use? What should really matter is putting the time and effort into marketing and selling instead of into the new technology.

**I'm sure you've found yourself talking to the top marketers and photographers around the world. The top photographers are using digital as a tool, as just one more thing in their arsenal, not something that's necessarily replacing the way they've done it. It's just one more advantage they can offer their clients to up-sell, to make more dol-**

lars, and to make their clients happier and more satisfied.

Exactly! Everything goes back to self-image psychology. I think there are photographers who are so insecure about the fact that they're not making the living that they want to make with film that they say, "Oh, it must be because I'm using outdated technology. If I put, oh, let's just say $50,000 into new equipment, my sales will improve. I'll have to borrow the money, but I'll get into digital, and then I'll learn how to use it! I'll learn how to use the software, too, then I can do my own retouching and oh man, this is going to be so cool!" Of course, they're losing sight of the fact that if they can't do it with film, they're not going to be able to do it with digital. We are marketers and sellers of photographic services. That's how we earn our living, and so if we don't invest a substantial amount of our time in the marketing and the selling aspects of our business, we're not going to be earning anywhere near the kind of living we should be earning.

**If you could describe in a nutshell what your marketing philosophy is, what would you say?**

The main thing is, you have to create a huge demand for your limited supply and then control the volume of work you do with the price.

**What do you feel are the most important attributes of a good Power Marketer?**

Well, there's no real secret. The main attribute is they devote the time, the effort, and the thought. They scratch off at least one full day a week, usually two full days a week, devoted strictly to marketing and selling. They won't take appointments, they won't answer the phone. They'll let either their voice mail take the calls or they'll have other employees and staff who will answer the phone. They know that the only way to create a huge demand for a limited supply and to earn a really good average sale is by devoting the time to get better at it and figuring out your marketing.

It's all a matter of having goals, and knowing where you want to go, and what you want to achieve, and how you're going to achieve that—and that takes time. There's no magic formula. It just takes time. So to me, the real difference is that the really good marketers are the people who devote time to it.

**Why do you think so many people, so many great photographers, find marketing, promotions, and advertising to be such a pain? Why don't they get more excited about it?**

Because none of us went into photography for marketing and selling. Why are we in photography? We love it! We're passionate about it. We're creating something from nothing. We're right-brained, creative, artistic people. So we go ahead and we put all this time and effort into the equipment and the methods and the technology and the f-stops and the vignetting and the diffusion and the depth of field and then we expect—because no one told us differently—that if we have a really good product, it will sell itself. People will line up at our door. It just won't happen that way.

The great Donald Jack, the one man who totally altered my life forever . . . it's just incredible what he did for me when I spent two years understudying with him at his studio in Omaha. The first time I went in to offer my services as an apprentice, he, to my shock, accepted my offer. He said, "I have a wedding this Saturday, why don't you go with me?" Oh man, I was so excited!

"The really good marketers are the people who devote time to it."

So, I got in the car to go to this wedding one Saturday morning. We loaded up the car with all of his equipment, and got in the car. He backed out of his driveway at the studio and he headed down the street toward the wedding. And the first thing he says to me is, "So, you're going to be a photographer, huh?" And I went, "Yeah, yeah, Mr. Jack. And I'm really excited. It's going to be really cool!" He said, "Really? Well how are people going to hear about you?" It was his first question. And I went, "Uh, Don, I'm going to be really good. I'm going to be so good that everybody's going to talk about me. I'm going to be really, really good." And he said, "So they're going to just line right up at the door to be photographed by you, huh?" And I said, "Yes sir, yes sir. I'm going to work really hard. I'm really motivated. I'm going to be really good." And he said, "Well, Chuck . . ." actually, I believe he said, "Well, Mr. Lewis, we've got a lot to talk about. . . ."

**And how old were you at the time?**
I was still wet behind the ears. I was in the Air Force. I must have been about twenty, twenty-one at the most. That's why so many photographers don't like marketing. Because they feel it's so undependable. You can't predict it, they think. You put in money and effort and work and you mail something out and it doesn't work, or you buy a yellow pages ad and it flops. They'd much rather have people just come in and sit down in front of their camera so they can create something nice and beautiful. That's what we do. That's what we love.

But this marketing thing . . . without that, everything else fails. And then how we present the photographs—without that, everything fails. We should be putting all of our efforts into that one decision because that's the single . . . like I said, the single biggest decision of our career is how we present the photographs to our clients. If we mess that up, it doesn't matter how good our photographs are. It doesn't matter, because we're not going to earn the kind of living we deserve.

So the whole secret really is to have a system where every single contact we make counts. We have got to realize that we're selling in everything we do. It's all about selling—not pressure and not trickery and not manipulation. It's just a matter of finding out what people want and helping them to get it. That's what selling is.

**What's most important to you in life, and how does your overall marketing plan come into play with those things?**
There's no question that my family and my time with my family is the single most important thing. When I started my studio I worked 100 hours a week, day and night, seven days a week. I loved it. And that's a huge mistake. You can't love it. You've got to love your family, but you can't love photography. You've got to keep things in perspective. My goal was to figure out how to earn a really phenomenal living in photography in forty hours or less a week, no nights and no weekends. And at that point, I was really big into weddings, and so I had no idea how I was going to do it, but I was passionate that if it was a choice between the family or the studio that I was going to dump the studio. And until that moment I had never thought like that.

If I had a client—a potential client that was perhaps going to end up being a good sale—I'd come in any day of the week, any time of the day or night because I needed that money. And so the end result

"This marketing thing . . . without that, everything else fails."

was I was always choosing the studio over my family. I was determined to work only certain hours of the week, and I had to figure out how to earn a really good living on only those hours, and that's when I started discovering all the things that I've put into my system of marketing and selling.

**How have you developed that balance between your personal life, your family, your hobbies, and your professional life?**
You have to have goals. You have to know where you're headed. Where do you want to go? I had goals and have goals, and I have objectives that I want to achieve. I've always had those in front of me, and I know where I'm headed. If you know where you're headed and are passionate about getting there, you'll get there. All of my passion is in spending time with my family, in taking trips. My wife Cheri and I love to travel. That's probably our biggest hobby. Not for work, but for fun. We want to see the world before we die. We want to see everywhere!

So I try to figure out, okay how can I earn the kind of living I need to earn on the hours I need to do it so I can take four or five months a year off to do the traveling and the other things that I'm interested in? And then we realize the 80/20 rule where 80 percent of the money in our pocket comes from 20 percent of the work that we do. And we start sending people away. As the great Donald Jack taught me, in order to be successful, you must be willing to send some people away. You cannot serve all people and be all things to all people. So we determined who has the greatest potential for helping us reach our goals, and those are the people we work with. And then we send the others away nice and friendly, diplomatically. But we send them away. We walk.

**That's tough to do sometimes, to say no.**
It's very tough. Especially when you're hungry. It's very scary, but it's absolutely a necessity. Otherwise, you're going to be spinning your wheels doing things that are not going to end up earning you the kind of money you need to earn and want to earn.

**What could you recommend to a photographer who is looking to make improvements in their marketing?**
It is all based on what do they want. I do a lot of one-on-one consulting with photographers all over the world, and we spend an hour each month on the telephone. I'm constantly harassing them with questions—Where do you want to be? What do you want to do? How many sessions do you want to do? What's the average sale that you want? What did you do last year? How many sessions? What's the average sale? Now break it down by the client type and the product line. How many families did you do? What was the average sale? How many weddings did you do? What was the average sale? Because you have to have the goals. And this is a very difficult thing for people to do because our parents didn't teach us this. Our teachers didn't teach us this. Most of our friends are not goal-oriented. Success is not normal. It's absolutely not normal. If we look around the country, most people are not what you would consider successful. They're not happy where they are, and they don't know what to do to change it. So it's very important that we have goals. I'd have to ask first: Where do you want to go? Where do you want to be a year from now? Where

> ## "You cannot serve all people and be all things to all people."

do you want to be five years from now? How many sessions? How many hours a week do you want to put into this?

**What is your hook?**

Your number one hook should be your guarantee that separates you from everyone else. You should talk about your guarantee all the time. When people are going to make a major buying decision, they're concerned about what happens if you don't deliver. What happens if things don't go the way you're promising me? People can promise anything. Words are cheap. So what happens if it doesn't turn out the way I want? In my humble opinion, my number one hook is our guarantee. We absolutely guarantee that you will be thrilled, not just satisfied, with your photographs. If you do not cry tears of joy when you see them for the first time, then we will give you all of your money back. No hard feelings. No hassles. If you're not thrilled, we don't deserve to have your money.

**How do you go about communicating your hook to your customers?**

The number one way is exhibits. The single best way to create a huge demand for your limited supply is through free exhibits throughout the community. And then on the exhibits you put not just a business card, but what is known as a lift card. The lift card communicates your top two or three hooks. It will have a headline, it's full of testimonials, and then has a call to action, which compels the prospective client to do something. Obviously the number one choice is to go to the telephone and call the studio directly. That's what we'd like people to do, and many of them do.

What we need our marketing to do is to get qualified people to call us. And we don't just mean rich and famous people that have lots of money. Yes, they do need some discretionary dollars, but that's not the key. The key is they need to be educated about how we do business, what is special about us—and they have to kind of agree with that. They have to say, "You know, I like the way this guy or this girl looks at photography. I love the emotion. I love the sensitivity. I like that. And I like the fact that, yeah, they're a little more expensive than the average photographer, but they're going to take really good care of me. They're going to spend a lot of time with me. They're going to meet with me ahead of time before the photography is done and advise me on clothing, makeup, hair, and locations."

This is the kind of thing I'm looking for. So when the telephone actually rings and there's a prospective client on the other end, they're more qualified. Therefore, the phone will ring less, but the booking percentage—the conversion rate, if you will—will be higher.

**When you're not working—and you've already told me that you guys love to travel—what do you do for fun?**

Travel is number one, because I crave stimulation. I love to learn history. I'm just passionate about history. So we love to travel all over the United States as well as to other countries and learn about their cultures and their history and the things that have happened in the world. That's just fascinating to us. Number two is I'm a radio-control fanatic! I fly radio-controlled airplanes and helicopters, and that's one of the hardest hobbies I've ever had. Especially helicopters. They're just absolutely awful to learn, and I'm just

"The phone will ring less, but the booking percentage will be higher."

getting past the hovering stage. I know how to hover.

**That can be an expensive hobby, too, can't it? Because if it crashes, it's toast, right?**
Yes! What I've always liked the most about radio-controlled flying is that when you are doing that, you cannot be thinking about anything else. You can't be thinking about business, can't be thinking about that sale you had yesterday and what you did wrong and should have done better. You can't be thinking about your next marketing campaign. You have to have 100 percent of your brain cells concentrating on that airplane or that helicopter or it's going to be going into the ground. I've always really enjoyed that.

My third hobby is fish. I like saltwater fish, which is another horribly frustrating hobby, because if you don't do everything exactly right, your fish die! At least if you crash your helicopter, you've crashed the helicopter. You're going to have to put a few parts into it, and it's going to cost a little bit, but I hate it when my fish die.

**How big are your tanks?**
I have a 55-gallon saltwater and a 29-gallon saltwater. My 55-gallon one just crashed a couple of weeks ago, and I lost all the fish. And I just take it all personally. I didn't do enough water changes. I didn't do this right.

So, basically there's three of them. The traveling and history, the helicopters and airplanes, and then the fish.

I had a friend in college who went out—and I don't remember what he spent on the kit—but he built his own airplane. I went with him one day out to this parking lot and this was in Fort Collins, Colorado. He took it off, no problem. Got it up in the air, and then he couldn't figure out how to turn it around and it just kept going straight and eventually he just nosed it into the ground. And that was it. It was so far gone that he couldn't salvage anything. But it was a couple hundred bucks he spent, I think. And that really put a damper on his spirits, and he decided not to continue with that hobby.

And there's the key! There you have it. Bingo! You just hit on the whole key to everything right there! He gave up. He quit. He had one crash. One lousy crash. He had a crash and he gave up. I just love eBay. I'm on eBay all the time because I can buy used helicopters for practically peanuts.

**From people that are giving up?**
That's right. They give up. They buy it, they build it, they crash it, and most of them fix it again and then they're too afraid. They're too scared to go out and fly it again, and they give up.

It's the same with many photographers who are learning to become good marketers. They try something once and then they stop. The key to success is persistence.

**What's your favorite food?**
My favorite food is absolutely, positively steak!

**What kind?**
T-bone and porterhouse.

**Are you a barbequing man? Do you like to cook it, or do you like to just eat it?**

> "They try something once and then they stop. The key is persistence."

I like both. But I often do a lot of barbequing at home with my wife. I know it's bad for you and I know it's red meat, but it's what I like!

**What about your favorite book or favorite author?**

Napoleon Hill and his *Think and Grow Rich*. No question about that. No hesitation. If you haven't read every book that Napoleon Hill has ever written, you are missing the boat. Another huge mistake that most photographers and all businesspeople make is that they study only with the people that are in their profession.

There are a lot of brilliant people in this world who are not photographers who can give us a great deal of advice. Napoleon Hill published *Think and Grow Rich* in 1937, and it's still a classic. That tells you how good this book is.

**Do you have a favorite movie of all time?**

*Back to the Future*. The first one. That's one of my all-time favorites. It's one of the best scripts I think I've ever seen put to a movie.

**Who is your biggest inspiration in life?**

Walt Disney, for sure. Walt Disney started with nothing and suffered enormous failures. His father told him he could never do it. He would never amount to anything. Why don't you face reality? You're just not going to amount to anything. Well, that was the kind of growing up he had. And he suffered a number of huge failures. He never quit. He never gave up. He would always keep going. He would always pick up the pieces.

I wear a Mickey Mouse watch because it reminds me of Walt. I have a statue of him holding hands with Mickey Mouse on my desk. I have another plaque over here on my other wall from Walt Disney that has a fantastic quote from him on success. He has enormously influenced my life because he would not quit. He would not give up just because it was tough. When the going gets tough, that's when the tough get going. He was that kind of a guy. In the face of impossibilities, he would not quit. He's my favorite, followed immediately by Donald Jack in photography—he altered my life forever, and I can never thank him enough. Finally, Harry Houdini. I really enjoy studying his life. He was a master marketer—one of the finest marketers there ever was. Harry Houdini's marketing techniques were phenomenal, and that's why people who are not in the field of magic still know who he was all these years after his death. Because he was a master marketer.

A couple of additional thoughts: Be thankful that things are so difficult. If it were easy, everybody would do it. And because everybody would be doing it, it would be really hard. But because it's not easy, most people say this is way too much work. You mean I've got to scratch off one or two days a week to put into marketing and selling? You have got to be kidding me! I don't have time to do that kind of stuff. I've got to get to work on my Photoshop retouching. I love Photoshop! So be thankful that things are difficult, because life is a pyramid and you have to determine where on that pyramid you want to be. I'm not the world's greatest photographer, and I'm certainly not the world's most famous photographer—and that's okay with me. I'm fine with that. I know how much I want to earn. I know the lifestyle I want to have. I know how many hours per week I'm going to put into this. I have other interests that have nothing to do with photography.

> "I'm certainly not the world's most famous photographer—and that's okay with me."

You notice I did not say one of my hobbies is to take photographs when I'm on my trips. I don't want anything to do with that. I've got to get away from photography. And yes, I'll take a cheap little digital camera, and I'll do some snapshots, but that's it. Hobbies are so important to have. You must have interests other than photography that can get other parts of the brain stimulated. That way, when you get back into the studio, you will be earning a really great living on as few hours a week as possible. After all, we're in a creative profession and we can't be creative 100 hours a week. We can't do it. Our brains won't let us do it.

So if you want to do the very finest work and have the finest successful business, you have to limit the number of hours you put into it. So if I can show you how to earn a really, really incredible living from your photography on thirty-five hours a week, then you're going to be so much happier because you're going to have other things to do that keep other parts of your brain stimulated. And when you are at the studio, you're going to be doing amazing work, because you're not burned out. You're not sick and tired of it. You're not worried about money problems, and you're going to become a better photographer for it, and a better person, a better father, a better husband, a better brother. That's what I'm all about.

> "We're in a creative profession and we can't be creative 100 hours a week."

# 5.
# CREATING VALUE— REAL OR PERCEIVED

So how do you create value for yourself? One of the key ways to create a higher perceived value is to underpromise and overdeliver every time. If you tell your customer their portraits will be done in four weeks, make sure they are ready in three. If you quote someone $500 for their portrait package, come in under that price. It's all part of giving your clients the positive experience that will reap rewards for years to come.

● **DEFINING VALUE**

Value is not the same as cost. Cost is what we pay to purchase something. The value of our products and services should be significantly higher than the cost, or the client won't have an incentive to buy.

Let's say you have a product in your studio that sells for $100 (or should I say you want to sell it for $100). I think most of us can think of a something in our studio meets one of those criteria. Through all your marketing efforts, advertising, promotional pieces, positioning, and image creation, you want customers to flock to your studio to pay $100 for

your Black Supersonic Whatsahoosit Widget. Now, whether you are successful at selling the Black Supersonic Whatsahoosit Widget is completely dependent on its value—or the "perceived value" it has to your client. So, will the widget be a hit? Basically, one of the following three marketing phenomena is going to take place.

First, let's imagine that your client's perception of your widget is $50, so you run a 50 percent off sales promotion in order to have a successful campaign. In the real world, this is a popular technique that's typically used in retail establishments—especially before and after the holidays. Retailers motivate us with a very deep discount to lure us into the confines of the store and hope that we will purchase more than the item that is 50 percent off. Grocery stores are famous for using a low-priced item to lure customers into the store. They run an ad stating that a gallon of milk is on sale for $1.49 (or $.29 black olives, or ears of corn 10 for $1.00), and on your way to the farthest corner of the store to pick up the milk, you pass large end cap displays towering with 600 rolls of paper

towels, or 1,000 cans of pumpkin pie filling, or cherry cordial for $.99. Well, you can rest assured those items carry with them a nice profit margin.

The stores know intimately through their marketing research that for every ten gallons of milk they sell at $1.49, they will also sell a fair number of other products as well. They make up for their discount on milk with sales from other higher-profit items. This technique is called using a "loss-leader" to get customers in the door, and it can easily be adapted to a smaller business. In our industry it's most prevalent in the high school senior market; photographers offer these clients sessions at pennies on the dollar, or free, to get them into the studio, then the volume is made up with sales from their packages and wall portraits. If you have a strong sales program and effective salespeople to work with, this can be an effective strategy.

In the second scenario, the client's perception of your widget is right at $100. Not more, not less. Right at $100. This is strategically worked to perfection by companies like Nordstrom, or The Bon Marché, or Lexus automobiles. They create a demand for their products in such a way that we will gladly pay the asking price, just so we can be associated with that product. It's more about our image and making us feel special than it is what price we pay. They have made us believe that the price really isn't that important. We want to belong to the "club" so to speak. When you go to a Lexus dealer, the asking price is also the selling price—no

dickering, no negotiating. If you want to drive a Lexus, this is the price. If you are a Nordy, someone who shops at Nordstrom, you know that they do not offer big sales, except for once a year. The rest of the year, we will pay pretty much their asking price. If you want what they sell, you pay.

In the third scenario, you manage to create for your product a perceived value of more than $100— maybe it's $120, maybe $150, maybe $200 or more. The greater the discrepancy between the selling price and the perceived value, the higher the level of motivation your customer will have for buying your product, and the greater the level of sales you will have.

● **ENHANCING PERCEIVED VALUE**

So, how do you create a discrepancy between the selling price and the value of the product? Well, in

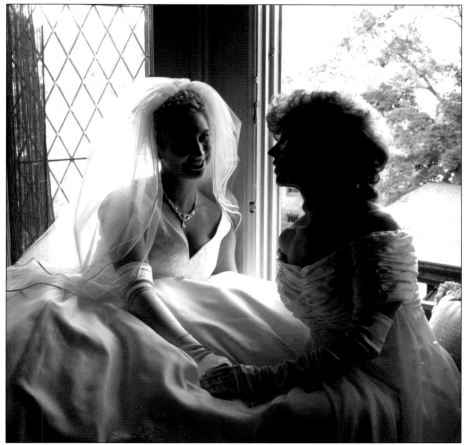

One of the key ways to create a higher perceived value is to underpromise and overdeliver every time.

this business, value is often added by including a frame at no charge, a free portrait, a mini two-way portfolio, or a no-charge session when they purchase that specified product. The sky really is the limit here, and the more creative you get, the better the client's response will be. Remember one of the basic rules of marketing: either you are different and unique or you are out of business. Find out what everyone else is doing, then don't do it. Run as fast as you can in the other direction. This is how you guarantee you will separate yourself from the rest of the pack!

I love a group called Mannheim Steamroller and their leader, Chip Davis. Many of you may recognize the name (and if the name doesn't ring a bell, you'd know their music if you heard it on the radio). You can walk into any music store year-round and find a big display of their music—and it's never on sale. Instead, they motivate us to buy this music by including a free cassette tape of holiday music, a free mail-order barbeque sauce kit, or a large tin of gourmet hot chocolate.

I am one of those people who will always look for the unique and different, and Mannheim Steamroller's approach to marketing is just that. With millions of album sales to their credit, I'm surprised more musicians haven't borrowed the technique! From personal experience, I can tell you the barbeque sauce goes great with chicken, and the hot chocolate is wonderful on those cold nights in front of the fire!

Another example of this technique is the infomercials on TV. The product spokesperson will spend the first twenty-five minutes of the show creating a value in our minds of $19.95, and most of the time, we probably believe that's what the product is worth. Then all of a sudden, they sweeten the pot with "If you call in the next seven minutes, we will include a second one absolutely free!" You see it time and time again; it obviously works or they wouldn't continue doing it.

If the value in the mind of the customer is greater than the

So the bottom line in marketing is simple: always give customers value that is greater than the price they pay.

asking price—*boom!*—you have a good chance of making the sale! So the bottom line in all of this is simple: always give customers value that is greater than the price they pay.

How can you immediately begin to create value (perceived or real) in your products that motivates people to want to do business with you? Remember that perceived value is strongly influenced by emotion, ego, and personal image—things that are intangible—and each of these should be considered in your marketing programs.

Here's a rule of thumb that I want to encourage you to make part of the fabric of your business: don't discount—give stuff away. Let me say that again: *don't discount—give stuff away!* When you discount, you penalize good clients and attract the price shoppers. Give your clients something for free that adds value to their purchase or brings some joy to their lives! The fun part for you, as a Power Marketer, is that you can do anything you want, so make sure your "added bonus" is something that potential clients can't get from any of your competitors. That way, you continue to gain ownership of your hook and category each and every day. Obviously whatever you do needs to make sense financially, and only you know what your restrictions and limits are.

One thing you will find as you begin to brainstorm and come up with creative marketing programs is that you will have some good ideas and some not-so-good ideas, and you have to be willing to try them both. An idea I tried a few years ago for my wedding business sounded great at the beginning but turned out to be a lot of work in the end, and I'm sure you'll see why once you read this story.

I was looking for an innovative idea that I could use to entice and motivate potential wedding clients to book with me instead of my competitors. Originally, I was going to use it for people who signed a contract at a bridal fair, but I ended up using it the entire year. My idea was this: for every one hour of coverage my client booked for their wedding session, I would provide one hour of limousine rental for free. So if the client had a five-hour wedding package, they would get a nice limousine for five hours, and it didn't have to be at the same time. That way, they could use it to pick up the wedding party from home, or shuttle guests from the church to the reception, or whatever they chose. Well, instead of working some sort of arrangement with a local company, I decided to just go out and purchase the entire company, lock, stock, and barrel!

The idea was a tremendous success. Our booking rate went through the roof, and we became the talk of the town. I hired a chauffeur, arranged all the necessary insurances, licenses, phone numbers, etc. Our clients absolutely loved what we did for them, but I had just purchased a business, complete with a toll-free number and yellow pages ad. The calls came in at 8:00a.m. Sunday morning and 11:00p.m. on Tuesday; people wanted to book wedding sessions, birthday parties, anniversaries, business get-togethers, and even sweet-sixteen parties. It was a real business, which meant I had to arrange coverage twenty-four hours, seven days a week for the phone and for a driver.

Many times I ended up being the chauffeur, the mechanic, and the person who washed the limo. The business did well, but it became very time-consuming and diminished my ability to provide my clients with something unique and different—something that would position my studio in their minds as a cut above the competition. After about a year,

> Our booking rate went through the roof, and we became the talk of the town.

I decided to sell the company and move on to other ideas.

The moral of the story is this: Regardless of the outcome of your ideas, you must be willing to risk failure in order to attain the highest level of success. You will not be able to discover new lands unless you risk losing sight of the shore. Be bold, be adventurous, and have some fun!

As you can see, creating value for yourself and your company can be achieved in a wide variety of ways. It's all up to you and what your goals are in life. It's very easy for us to fall into that old management trap and get caught up in the day-to-day details of running our businesses. We end up running our studios instead of designing our lives. We all fall prey to the day to day stuff—answering phones, meeting with clients, masking negatives, managing our digital files, ordering supplies, and mowing the lawn. Before we know it, our free time is gone, and there is no time for the things in life that are truly important, like family and personal hobbies. You're working Friday nights, Sunday mornings, holidays. You don't have time to play with your children, or to take a drive with your family along the lake, or to read that good book you've been meaning to get to, or to practice your putting at the golf course. The things that are most important to us start slowly slipping away, and we become a slave to our business rather than its master. I encourage you to go back and read chapter 1 from time to time to keep yourself honed in on what's important in your life.

Whether you want to be the Cadillac in your market or the Volkswagen—and there is plenty of room for both—adding value to your customers' lives should be one of the most important aspects of your marketing philosophy. There is always a way to add value, whether it be real or perceived. Not

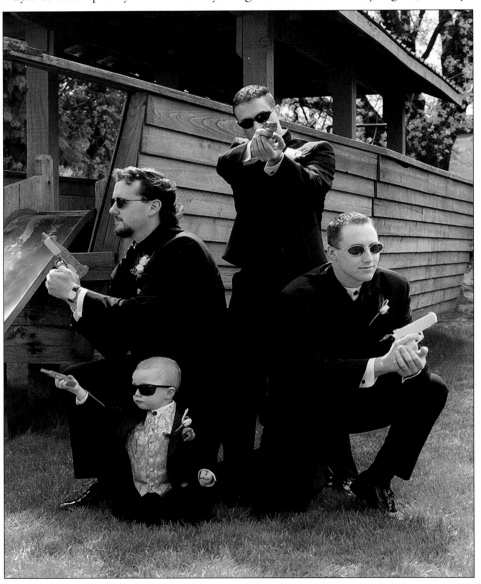

Regardless of the outcome of your ideas, you must be willing to risk failure in order to attain the highest level of success.

everyone can be the Cadillac (in fact, there's only one), and not everyone wants to buy a Cadillac. The truth is, there are a variety of widely respected models, and there's plenty of room for each of them in the market.

It's okay to borrow ideas from others within our industry and to incorporate strategies that we find outside of our field, just as long as they will benefit our business. You don't need to reinvent the wheel; just find an existing idea and customize it to meet your personality and style. Since you can't be all things to all people, find out what you are really good at and make it your trademark, your personal stamp. The day of the jack-of-all-trades is long gone, and the age of specialization is upon us. So decide what position or niche you want to occupy in your customers' minds, and be sure that everything you do will help you to achieve your goals and objectives.

*There is always a way to add value, whether it be real or perceived.*

Before we move on, I would like to share a few more thoughts with you. First, I hope you'll remember that we have the honor and the privilege to not only sell fine products and services to our clients, but to sell ourselves as well. Remember that believing in yourself and your abilities as a professional photographer and a Power Marketer can bring you rewards too great to number. You must also keep in mind that the challenge of creating effective marketing programs in order to achieve your desired position in the market can be difficult at times. In order to stand out, you'll have to separate yourself from the crowd; however, the process will also be one of the most fulfilling and rewarding experiences you will ever have. Separating yourself from the rest of the pack is never easy, but it can take you to places you never dreamed of—*if* you are willing to take the risk. Life is *not* a spectator sport!

## FOCUS ON . . .

## RICK FERRO AND DEBORAH LYNN FERRO

From stunning imagery, to cutting-edge marketing techniques, Rick and Deb have developed a surefire approach to business success.

Rick Ferro is one of the leading wedding photographers in the nation. In addition to countless brides and grooms, his clients have included 7-UP, Sprint, the Miami Dolphins, MasterCard, and Mercedes Benz, just to name a few. In 1993, Rick became the Senior Wedding Photographer for Disney, and Walt Disney World became the world's most sought-after wedding destination! After three years with Disney, Rick decided to freelance at Disney so that he could pursue other creative ventures.

Deborah has been on the fast track in photography since 1996 when her passion for photography became more than a serious hobby and she opened her first studio.

For more information on Rick and Deborah's educational materials for professional photographers, visit www.ferrophotographyschool.com.

**Mitche: What do you feel will be the biggest challenge our industry faces in the future?**

*Deb:* I believe our biggest challenge will be digital workflow. We are both film and digital, and we are constantly working to get our exposures right. Photographers are just picking up their camera and going with it, thinking they can correct any problems in Photoshop, and it's just eating up all their time. This creates big problems.

*Rick:* I just can't let my film go, and I know a lot of other photographers are in the same boat. Customers are looking for a quality in my work that only film can give me, which causes some workflow issues for us. I know some photographers who are going back to film after a short stint with digital.

*Deb:* So, until we make the total transition to digital, the biggest challenge is in workflow.

**What is your core marketing philosophy?**

*Deb:* From a marketing standpoint, the biggest questions we get are where do people even start to market themselves, and how do they know where to spend their limited dollars? That will differ depending on your market. The way we do things will be different than somebody in a small town. Also, we're challenged to educate the public in the difference between a professional photographer and an amateur photographer.

What do you want to be your share of the market? There are all different kinds of clients out there at all different income levels. Where do you see your photography studio? We believe in going for the gold! Instead of working our way up to the client we eventually want, we believe in targeting that client first. From our image presentation through promotional pieces, to our advertising dollars, to our pricing, to the way our studio is set up, we are focused on that market. We believe that we are selling ourselves and that our images are an extension of ourselves. You

only have five seconds to make a first impression! Everything from answering the phone, to your studio's appearance, to your marketing pieces, they all have a tremendous impact on whether you will procure the client. Do you know how many times people change doctors because they have lousy bedside manner? People connect with personalities and how they are treated.

So many photographers tell me that the reason they don't have the images we do is either because they don't have beautiful clients or the kind of higher-income clients that we have. Because you sell what you show, you should create a portfolio filled with images of the kind of client you want to have! How? Set up a photo shoot in your area at either a beautiful location or the type of reception location you would love to photograph at regularly. Get together with area vendors like a florist, bridal salon, vintage car or limousine service, and modeling agency, then offer to give images in exchange for them helping with the photo shoot. Make sure your name is on each image you give the vendors so their customers will see it. You are now in control of the quality of image you want to present and market with.

> "Being able to create great images doesn't pay the mortgage."

**What would you recommend to someone who is trying to take their marketing to the next level?**
*Deb:* Remember that *you* make the phone ring. How? Have a plan—let's say, for example, a direct marketing piece or a bridal show—and a way to implement the plan. Then take action to implement it and follow up. Don't wait for the phone to ring—go out and get people to call by getting involved in your community through the Chamber of Commerce, charities, networking with vendors, and by visiting local businesses and leaving your business cards.

Gloria Daly, a photographer who works with us, shared something she heard a long time ago that really stuck with her: "He who has a thing to sell and goes and whispers in a well is not as apt to get the dollars as the one who climbs a tree and hollers!" Just get out there and do it!

**What is your biggest asset as a power marketer?**
*Deb:* Our biggest asset is that we are in control of our client base, the direction of our photography, and our level of success. Success doesn't just happen, *you* make it happen!

**What do you feel your hook is?**
*Deb:* Clients come to us for the romantic location portraits we show on the Internet and through our advertising. Securing them as a client involves convincing them why they should choose us over all the other photographers out there. Our hook is that we tell our clients that they are not only hiring a photographer but also a graphic designer. With our ability to creatively enhance our images through Photoshop, whether we are retouching or designing our own digital albums, they are assured of a quality product unmatched by a mall studio.

**Do you think power marketers are born, or can it be learned?**
*Deb:* I believe that we are all born with a certain level of talent, but how we develop and use those talents makes a difference in our success. A great idea is worth a dollar, and a plan to implement the idea is worth a million, but without action you never see the money! Most people did not get into this business to make a million. They got into it because they had a passion for creating images. Being able to create great images doesn't pay the mortgage, though!

Selling great images pays the mortgage. It takes both.

**How long have you known each other?**
*Rick:* About 2½ years.

**You met, you fell in love, you merged your businesses and your lives. Tell me about the quality of life that you share.**
*Rick:* Quality of life to me is very important, and I've been fortunate so far in my life. I've been around the world twice on a ship, and I've worked with the Dolphins. I've had three studios, and I set up Walt Disney World's photography department in 1993. So, I had some really great jobs, but it doesn't even compare to how things are right now. I never really had the chance to share my life with anyone like this before, and Deb is such a huge inspiration to me. My photography is getting better all the time, and I'm opening myself up to new ideas and areas that I never would have done before.

I'm having the best time, and it's because of her, actually! I get so excited that I can't sleep at night. I get so excited about my photography.
*Deb:* It's actually because of my cold feet!
*Rick:* If it all ended tomorrow, it would be totally fine because I would still have her! We are like two little kids!

**How do you balance your personal and professional lives? Are there specific times during the week that you call "downtime"?**
*Rick:* We try to go to a movie on Friday nights and also try to go to dinner during the week. Sundays we try not to do anything. In our house, I'm the chef; I enjoy cooking as much as photography. If I wasn't a photographer, I would probably try to enroll in culinary school to become a chef. Deb makes great reservations!
*Deb:* I do the desserts and the breads and stuff like that. We love to entertain, so we are constantly cooking. I love the fact that we can have a nice lunch and spend that time together talking and taking some time out.

Our first year in business together, we used to take a lunch break and play a game of backgammon just to get our minds off the business and laugh. It has been so hectic this past year, that we really had very little personal time, and we didn't even get to go home and see Rick's family. We also make it a point when we travel for business to take a couple of extra days just to spend time together.

**Do you have any children?**
*Deb:* They range from age twenty-three to thirty-three.
*Rick:* I have a rubber ducky that we keep in the pool!

**When you are not working, what do you do for fun?**
*Deb:* Painting was always my release before I got into the photography industry.

**Do you still paint?**
*Deb:* I do in Photoshop! Every now and then when I go to an art gallery, I miss the smell of paint; but when I think about the control I have in Photoshop, and especially in Painter, the feeling passes!
*Rick:* I enjoy cooking. We enjoy good wine and good food!
*Deb:* Yes we do. We love to go out to a nice restaurant and spoil ourselves, and we absolutely love to travel also.

> **"Quality of life is very important, and I've been fortunate so far."**

**What is your favorite food?**

*Rick:* I love Italian, but I also love a big ol' steak!

*Deb:* Anything my husband cooks! It used to be seafood, but I can now honestly say that my favorite food is anything Rick cooks. I'm so spoiled that whenever we go to a restaurant, I won't order Chicken Marsala or Chicken Francesca because *nobody* makes it like he does!

**Favorite movie?**

*Rick:* *The Godfather* series.

*Deb:* I love all movies! I like romantic ones.

**Do you have a favorite show on TV?**

*Deb:* We used to be addicted to *The Sopranos,* because Rick is from Rhode Island and he's Italian. There is so much about Rick's life that parallels the show, except for the heads getting cut off!

*Rick:* I really show my Italian side when I go back to Rhode Island.

**Favorite book?**

*Deb:* *Jane Eyre* by Emily Brontë. I also love the *Thornbirds* and any books dealing with self-help or leadership skills.

> **"If I could only be half the person she is, I would be very happy."**

*Rick:* I like history and Civil War books. I also read recipe books from time to time!

**Who are your biggest inspirations?**

*Rick:* Don Blair and Monte Zucker for photographers. I had a teacher when I was in school named Mr. Williams, who gave me a lot of really good tips about life.

*Deb:* My mother. She's a very spiritual person, and if I could only be half the person she is, I would be very happy. She has more energy than I do; and because of her character, I admire her more than anybody I have met in my entire life.

**Do you have a favorite quote or saying?**

*Rick:* "I'll make you an offer you can't refuse!" (from *The Godfather*), "Leave the gun, take the canolies!" (also from *The Godfather*), "Leave the camera, take the pixels!" (*not* from *The Godfather*).

*Deb:* "If you do what you love and are passionate about it, the money will follow." It's taken me a long time to believe that it's worth going after your dream to achieve what you really want out of life.

# POWER CORNER

## FOCUS ON . . .
## DOUG BOX

Besides being a dynamic writer and speaker, Doug Box is also a man who enjoys life to the fullest! This interview was done on a sunny day in Canada, sitting outdoors with a cold drink in hand, resulting in an interview with a relaxed, informal tone. His laughter is contagious, and spending too much time with him can put a permanent smile on your face! His vigor for life and for sharing his techniques with other photographers has made him one of the most sought-after instructors across the country.

The originator of the revolutionary concept of "prime time" and "minimum orders," he is a pioneer of marketing in the new age of electronic imaging and color copiers. For years, Doug has been inspiring photographers of all levels to go beyond the normal and create a more successful and creative business. He is the publisher of the *Photographic Success* newsletter and has written several books, including *Professional Secrets of Wedding Photography, Professional Secrets for Photographing Children,* and *Professional Secrets of Natural Light Portrait Photography,* all from Amherst Media©.

For more information on Doug's seminars and educational materials, visit www.simplyselling.com.

**Mitche: What do you feel is the biggest challenge that faces our industry in the future?**
*Doug:* To me, it's charging for your time. Photographers are notorious for undervaluing their time, and they tend to give it away or do extra things just because they want to. Down the road, I see that being the biggest problem with going digital. Of course, photographers are going to get better with the equipment and the software, and it will be a whole lot more plug-and-play, but they're still going to have that opportunity to do a lot of things, and as long as they charge for their time, they'll be okay. If they start giving it away, it's going to just kill them.

**It's almost like the digital revolution is the core problem, but one of the side problems that develops is that you spend too much time in front of your monitor.**
And that's okay, if you feel it rejuvenates you. I can't argue with that. Maybe at some point photographers will be able to delegate things. Of course, with any business, being able to delegate so that you don't have to do every single thing, whether it's digital or film, is the end goal.

**What's your marketing philosophy in a nutshell?**
For me, it's a referral business. I've been studying this and I've realized that there's a great difference between a word-of-mouth business and a referral-based business. In a referral-based business, we have systems in place to do things—to get referrals, to thank people for their business for instance. Our business is built on referrals. We talk about it with our clients ahead of time, telling them that I can only earn new referrals if, at the end of the whole process, they still like and trust me, and I have delivered above and beyond their expectations. I ask them, "If I do all of those things, will you send me your friends and family?" and then I just wait for a response.

Saying this to the client is almost like raising your hand and promising those things. I'm saying to them, if I fill my end of the bargain, I expect that you'll do your part too. And they all say, "Oh, sure. . . . In fact, I've already told two people about you." That's typical.

When I get referrals, I sell the benefits of hiring my studio, not just the features. The benefits should be carefully worded, though. A good example of that is, "I've been in business for thirty years." Well, if you're not careful, it's going to sound like you're just old. But if you can tell them the thirty years' experience is good because you can handle any situation, because you've seen it all, and because, if they run out of time, you can still get them good images, then that experience is a clear benefit. So, you have to talk in benefits, not just features.

**What do you feel are the most important attributes of a Power Marketer?**
I think its the ability to make the time to do it, because it's so easy to put that type of thing off.

**You mean mapping out a time in your schedule to sit down and work on your business?**
Yes! There's recharge time, which for me is like getting away from everything and just recharging my batteries, so to speak. So that I can come back into it clear-headed. Because if you work twenty-four hours, seven days a week, you're going to burn out so much quicker. Again, aside from scheduling time for yourself, you should also schedule a time to work on your business. Otherwise, it's too easy to just put it off. You can say "Oh, I'll do it next week," or "I'll do it tomorrow," then something happens tomorrow.

Vacation's a perfect example. Most photographers have never taken a two-week vacation. Maybe they get to go to a school and take a couple extra days off, and they call it a week's vacation. A vacation is totally different than that. So, at the beginning of the year I think it's important to schedule time off for yourself and for your family and to use that recharge time. Schedule time where you're working *on* your business. Not just *in* your business. And stick with it. Don't give that time up. That's as valuable a time as photography.

**You mentioned family. What are the most important things to you in life, and how does your marketing help you accomplish your goals?**
My family. Of course, they're very important. My kids are in college and grown, so I don't spend as much time with them as I used to. But I spend a lot of time with my wife and my parents and my sisters—and again, I think it goes back to planning time for yourself. Right now, quite honestly, I've bought this motorcycle, and I'm having a ball on it! I never thought I could retire until I bought this motorcycle. I could retire this afternoon and just take off on the bike. And still do some things. The teaching is fun for me. It's fun to be able to do this. I'd like to take a week and just ride to some destination, teach for a week, and take a week getting home. Make a three-week deal out of it!

**How do you balance the professional and the personal life that you crave so much?**
You know, it's hard, because I think most of us love this business so much. When these guys sit down and do the digital techniques, it really is fun. It's fun to see, to be creative again. I think that's what digital is—an awesome, powerful tool that allows you to go in and do anything you want. The most important

> "If you work twenty-four hours, seven days a week, you're going to burn out."

thing is being able to charge for your time and not give it away and to schedule that time. I think that scheduling is the biggest thing.

I try to work in two-week blocks, because if you don't, all of a sudden, you have no time. But if you schedule yourself out two weeks at a time rather than three days at a time or two days at a time, you're able to include time for yourself and your business. And then having the willpower to stick with it and just saying, this is the time for X. On our answering machine, instead of just saying, "Leave your name and number, and I'll call you back as soon as I get back," we say "Leave your name and number and I will return my calls on Friday between the hours of 2:00 and 3:00 p.m. and 5:00 and 6:00 p.m." This makes your job more efficient and helps clients, since somebody might leave you a message saying that in the morning they are at this number, and in the afternoon they are at this number. If you're not specific, they don't even know—you're not giving them any parameters. Now, when we're gone to a seminar like this, we let them know. We're going to be at a seminar for a week and we're learning new customer service ideas to be able to come back and serve you better. So, we're not just saying we're off at a conference, because they'll think we're screwing around.

**Does Barbara travel with you?**
No, she doesn't like traveling as much as I do. She's got three dogs, and she likes staying at the house and sleeping in her own bed. I think that scheduling things, systemizing it, and just taking control of your time and your life is important.

**What about somebody who's just getting into the industry or who has been around for fifty years—**

*"Taking control of your time and your life is important."*

what one or two things can you recommend that they do to take their marketing and their business to the next level?
One of the things, I think, is education. Going to schools and seminars. For twenty-one years I've been going to schools and it advances you. One of the things I would tell people is when you take the time to go to a school or a convention, schedule some time afterward to implement some of the things that you do. Because so many times, you go to the school, you get home, and you're so far behind that you don't have time to even try any of the new things you just learned. You end up forgetting most of what your learned; if you don't try them real fast afterward, the new skills are gone—either they're out of your memory or you haven't had a chance to test them. So by scheduling a week for the school and then two or three days afterward to start implementing these things and get caught up . . . I think it would help you to actually use the things you learn. I voraciously read marketing books and listen to the tapes. I love tapes. I drive a lot, so tapes work. I've got a bookcase that's three feet wide and six feet tall that's full of nothing but marketing and sale things. I get as much enjoyment and excitement out of making a new marketing plan and writing a marketing letter as somebody else would out of sitting in front of Photoshop and doing photographs. It's exciting! Quite honestly, it's more fun for me to book a wedding than it is to shoot a wedding. I love booking them.

**What is your hook?**
Let's talk about weddings, because that's what we do most of right now. One of the things that make us different than everybody else is that we have two

photographers. My wife shoots and I shoot. She shoots black & white and photojournalism, and I do color. As I tell brides, having two photographers—two different people, two different viewpoints, and the fact that one of them is a woman—makes all the difference in the world.

I really do believe that women look at things differently. They really do. Men tend to be a little more analytical and worry more about the f-stop and the lighting, and they're more into the emotional aspects, as I think brides are. And so for us, having two photographers, one being a woman, really helps: women can go places that a man can't go and that benefit just separates us from everybody else. Not everybody else has that opportunity, but for us it's a big draw.

**What is your most successful marketing philosophy or campaign that you've done or that you do on a regular basis?**
You know, because my business is referral-based, I don't have to do much marketing anymore!

**So, having a referral-based business is your main focus?**
That's exactly right. I did an analysis last year and about 25 percent of my business came from past clients. About 25 to 30 percent came from other photographers that referred clients to me. About 20 percent of the referrals come from the trade. The other part comes from different areas. Almost none of it comes from yellow pages, our website, or anything like that. I get a lot of calls from those places, but they don't turn into business. So, we're cutting our marketing effort. We're still doing a bridal show, and we struggle with that every year, because we typically go with all our dates booked anyway. But we're concerned that if we don't show up, people will go, "Whatever happened to that other guy? Where is that guy? I know he's always here."

But we're getting to make marketing simpler. Another important thing is to stand out. About four or five years ago, I guess it was like '98 or so, we brought black & white photojournalism into our area. We certainly didn't invent it. But in our area nobody else was doing it. So, we introduced it to our area. And it was huge. I mean, there was a real buzz at the bridal fair. Well, the next year everybody was doing black & white too, and so, to the untrained eye, they all looked the same. All of the photographers had color, black & white, albums, prints. It all looks the same unless you really sit down and look at it—even to photographers. I mean, everybody can get a good picture every once in a while. And so we're looking at ways to make us stand out. I think Barbara's work is one of the things that does it. It's so different than everybody else's. But, again, everybody is following, and so, if you want to be a leader, I think you have to have something unusual and different that you do.

> **"You have to have something unusual and different that you do."**

**When you're not working—and you already told me about your new bike—what do you do for fun?**
Camping. I like to do some backpacking. Right now it is the motorcycle. I mean the bike is just so much fun for me!

**How many days do you ride in a week?**
When I bought the bike in November, I put 2,500 miles on it the first month.

**Is your studio at your ranch?**
Yeah. I live on 100 acres.

**So, you don't get to ride your bike to work?**
No. But I try to ride once or twice a week for a little while. I haven't made any really long trips yet, but it's coming.

**What's your favorite food?**
Oh man, the sad thing is, all of them. I'm bad about sweets. I love them!

**Favorite movie?**
I was just thinking about that the other day. I'm a softy!

**How about your favorite book or author?**
Louis L'Amour. I love reading him.

**Have you read all of his books?**
Not all of them, but a big chunk of them.

**What about the best experience you've ever had?**
As corny as this sounds, the birth of my kids. They're good kids. Also, I was teaching at a school one year, and my son was in a really bad accident, but he came out of it okay. That was a miracle. It turned his life around. It really made me stop and think a little bit about life.

**Who are your biggest inspirations?**
Brian Tracy is a big one. I'd like to meet him. Also Dan Kennedy. I'd have to say for me as a speaker, Don Blair. I remember watching him years ago, thinking, I want to be like Don Blair. And it was a goal that I set, to be recognized as a good photographer and be respected as a teacher. And having the staying power like he has. Don's been doing it for a long time, and he continues to do it. And he was one of my early guys that I wanted to be like. If I could be like anybody, it would be someone like that who is respected for photography, teaching, a fun guy, a liked guy, the whole package.

I think you've got to do what you love. And that's the beauty of our business. For the most part, I love everything about it, and if you don't, get out of it. Do something else. Life's too short!

> "I remember watching him years ago, thinking, I want to be like Don Blair."

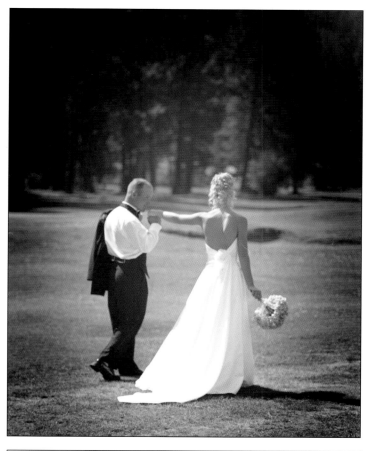

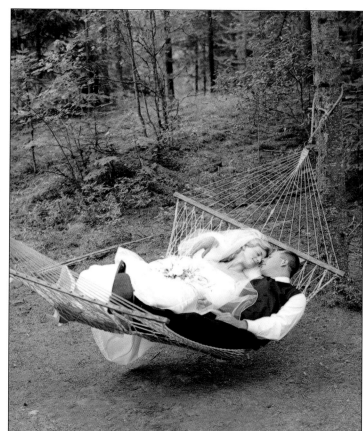

# 6.
# IMAGE
# IS EVERYTHING

I want to take you on a journey to a place where everything is perfect, where there is no stress or worry, and the streets are made of cheese! It's a place where you can buy anything, do anything, and be anything you want to be. This place is called your mind, and it's the most powerful tool we have.

Imagine it's a beautiful, warm Sunday afternoon in the fall, and you decide to go for a drive in the country. With all the hustle and bustle of everyday life, you don't get this opportunity as often as you'd like, but today is your day! As you drive along, you decide to head over to a nearby lake that is known for its vibrant fall colors and tranquil silence. As you drive along the hillside, you notice that the leaves on the trees are slowly beginning to fall softly to the ground, and they create a bed of color on the pavement in front of you. With the window down, you can feel the wind tickle your face and smell the familiar scent of autumn.

The sun is directly in front of you, and as it hits your face, you feel the warmth of its rays. It's a feeling you crave and relish, and you want to soak up as much of this feeling as possible before the season passes and winter digs in. You come to the road that will take you to the lake, and you take notice of the fact there are no other cars coming or going. The road is yours. You begin to feel the excitement of being at the lake by yourself and taking in all it has to offer.

As you approach your destination, you find a place to park your car, and you begin the short walk down to the lake. You are about a hundred yards or so from the bank, and you notice two little stores next to the road—one on the left and one on the right. Your eyes are first attracted to the rustic brown building on the right. There is a bike laying in front of the store, and you can tell it has seen better days—the handlebars are covered with rust and several of the spokes are missing from the rear tire. You notice that the shop itself has a broken rain gutter that is filled with rotting leaves from last season, and the grass hasn't been cut for quite some time. The aged, painted dark-brown trim around the windows and door is beginning to chip, and there are a couple of spiders

that have made their home in the upper right corner of the front window. The sign above the door reads Lakeside Quick Mart. The smaller sign in the window below the spider web reads *Lemonade 50¢* and *Cookies 10 for a $1.00.*

Your eyes then meander to the little white building on the other side of the road. There are bright red geraniums neatly planted in oak barrels that are placed along a cobblestone walkway leading up to the front entrance. The pristine line of white picket fence that surrounds the entire building is punctuated with tulips, and a mailbox in the shape of a trout sits atop a cast-iron stake. On top of the building rests a sign, freshly painted in blues and yellows, and greens. It reads: *Heaven on Earth Country Store*; and then, on a smaller sign below, the words *Where Friends Meet* appear. It almost makes you feel like you did when you were at Grandma's house when you were little—it seems to be a safe, kind, and friendly place. You notice a small sign in the window that says *Hand-Squeezed, Country-Style Lemonade—Made Fresh this Morning—Only $2.00 a Glass.* Your mouth begins to water as you imagine drinking that glass of hand-squeezed, country-style fresh lemonade. The side windows are open just a crack, and you can smell fresh chocolate chip cookies, which must have been pulled out of the oven only ten seconds ago. You would pay just about anything to have a bite of one of those cookies right now.

You pause for a moment, glance at the brown building on the right

side of the road, and then you turn your gaze again to the white building on the left side. You have to make a choice as to where to go. In a split second, your mind is made up!

Was there really any doubt as to which business you were going to go into? I didn't think so! It didn't matter that the lemonade was $1.50 more at the store on the left, did it? It came down to the image that each business created in your mind. And once that impression is made on our minds, it's virtually impossible to change how we feel. The Quick

"Power Marketing Man" was created as a fun way for photographers to remember my workshops and seminars. He begins each of my programs with a little dance, some door prizes, and a lot of energy! What was started as a simple way to create some excitement has actually turned into one of my "hooks" for my programs. He gets as many requests to make appearances as I do! (Photos by Mark Huender.)

One of the marketing niches that we have developed in our market is the "fun and crazy" position.

Mart may have had the best cookies in the world, but the business owners sure didn't do much to convince us to give them a try—no matter the price!

Clients judge us long before we expose a single frame in our cameras. As a matter of fact, humans make judgments about people, businesses, food, and other products within *five* seconds! That sure doesn't give us much time to form a favorable impression and to instill the value of our products.

As business owners, we must always be prepared to be judged. After all, every business decision we make—from marketing, to positioning, to image creation—expresses to clients who we are and what we do. When a prospective client enters your business, they evaluate what you wear, how you look, the way you walk and talk, and the general way in which you communicate with the rest of the world. It's as much about essence as it is substance! Most of us have been working for years to figure out the magic of marketing, yet we are met with a great deal of frustration. We are constantly trying to reinvent the wheel instead of looking outside the box for the answers. We earn our degrees from the school of hard knocks!

While there is usually a simple solution for overcoming most obstacles, we don't always see it.

History is filled with such examples. For instance, though man's discovery of fire was huge, it took us over a million years to figure out how to utilize it. While ice cream was invented around 2000 BC, the ice cream cone came about around a hundred years ago. In 1775, the flush toilet was invented. In 1857—eighty-two years later!—toilet paper followed. We are surrounded with simple solutions to help us succeed—we just don't always see them! Some of the simplest solutions are right in front of our noses, yet we can't see the forest for the trees. Creating a positive image can be accomplished by first addressing the little things.

Having a well-defined marketing plan and a positive image will not only ensure your survival in difficult times, but it will also allow you to outshine your competition. With a clearly defined plan, you will prosper even in tough times because you will be one of the only people in your field who markets smart. P. T. Barnum used to say he knew that half of all the money he spent on advertising was wasted—he just had to figure out *which* half!

You can avoid making costly mistakes by learning from other people's errors and from borrowing valuable lessons from other industries; there is nothing

wrong with that! You should make it a point to study the leaders in our industry and in others fields and learn what it is that gives them their competitive edge. Then you'll need to go out on a limb and put those tools to use. After all, when you do things the same old way, you should expect the same old results. If you hit your head against a wall and it gives you a headache, you should stop doing it! To progress toward your business goals, you'll need to spend time observing and studying the most successful and innovative people. (You'll take a step-by-step approach to this process with the Five-Second Image Challenge a little bit later.)

As photographers and businesspeople, we make mistakes every day, but the most successful people in our industry are the ones who learn quickly from those mistakes and then make the necessary changes to ensure that they don't make them twice.

## ● THE FIVE BIGGEST MISTAKES PHOTOGRAPHERS MAKE

When it comes down to our marketing efforts, most of our mistakes lie within five distinct areas, which are outlined below.

**1. Failure to Have a Well-Thought-Out Marketing Plan.** Anyone can captain the ship when the seas are calm; however, a good marketing plan does its best work when the seas are anything *but* calm. Eighty percent of all businesses do not have any form of marketing plan at all, and 80 percent of all businesses aren't around in five years. Do you think this is just a coincidence? We have two jobs—to photograph and to market; everything else is secondary.

**2. Failure to Have a Clearly Defined Hook or Message.** Without it, you are just a "me too," an also-ran, another run-of-the-mill business. You will

> Eighty percent of all businesses do not have any form of marketing plan at all.

not become successful simply because you are the best. Da Vinci was dead for over 200 years before he became famous. I don't want to wait that long!

You need to know what it is that makes you special and unique in your marketplace. What is it that customers can't get from anyone but you? What is the compelling reason that customers should come to your studio instead of any of the others in your area? Again, the numbers speak for themselves: 80 percent of all photographers couldn't tell you what their hook is if asked. Are you one of the 80 percent, or are you among the 20 percent?

**3. Failure to Have Professional-Looking Marketing Pieces.** It's all about first impressions. Everything you do must match your image. If you want to be known for Cadillac quality, then everything you do should be consistent with that goal.

**4. Failure to Project Your Sales and Goals into the Future.** Let me ask you a question: If a bride calls you today to find out more about what you have to offer, when is she more than likely getting married? Maybe six, twelve, or eighteen months from now? Then why do we give her today's prices? Shouldn't we be charging prices that are based on and reflect where we want our studio to be at that later date?

All of our *future* goals for our business (and our lives) must be reflected in our *current* price list. If your goal for next year is to shoot half the number of weddings at double the price, then next year's prices should be in effect—today! Or, on the other hand, if your goal is to shoot twice as many weddings at half the price, you should take all of that into consideration when designing your wedding collections today! Wedding photography is one of the only industries where we are hired and retained for a job we will perform at some point in the future. And we

should be charging those future prices today. Doesn't that make sense?

**5. Failure to Price Your Packages to Allow for Costs, Overhead, and That Four-Letter Word: Profit.** The average photographer makes less than $25,000 per year. Do you have a thorough understanding of your cost breakdown on your products? Do you know how much profit is generated from each sale? How many weddings do you need to book (or seniors or families) in order to achieve your financial and personal goals? What do you want to make this year, next year, and the year after that?

The biggest problem in our industry isn't that we are priced too cheaply, it's that we are afraid to charge what we are worth. Understanding what it costs to produce each of your products can give you the basic tools to make sure you are making a profit each and every day! There are some wonderful resources available that will walk you through the process of figuring out what your costs are—and what your profit is. I encourage you to investigate this topic as part of your brainstorming and planning sessions. Ask yourself, Do you want to be average? Or do you want to be successful? It's up to *you!*

If you would like to eliminate a certain segment of the business you currently do (let's say, for example, the low-end children's market), then devise a game plan *today* that allows you to smoothly exit that market and replace it with sales from your more lucrative demographic. In order to truly focus, you have to do *less.* You can practice hand-grenade marketing—just throw a bunch of stuff out there and hope it hits the target—or you can use laser beam marketing and hit only what you want.

If you want to attract a $50 client, then photograph a $50 client. If they like you, they will tell their $50-client friends about your work—which means you will be photographing $50 clients. If you want to photograph brides and grooms who want to invest $199 in their professional portraits, photograph one, and you are bound to get more! If you do a professional job and remember the value and power of the all-mighty referral, your clients will come to you informed about your quality, process, and pricing—thanks to winning testimony from previous clients, a new batch of clients will arrive at your door already sold on your abilities.

Once a client forms an impression, it's difficult to change their mind.

As was mentioned earlier, however, you need to carefully establish your market position, because once a client forms an impression, it's awfully difficult to change their mind. If you went after $199 clients and word got out about your good work and unbeatable products, how could you then convince those same clients that they should invest $5,000?

The truth is, you'd have quite a battle on your hands to substantially increase the level of their investment. Now, there *is* profit in the $199 customer, but you need to photograph a lot more of them than you do the $500, $1,000, or $5,000 customer.

It all comes down to what your goals are in life. Sometimes you are better off going fishing than taking a job that doesn't help you achieve your ultimate objectives and professional goals. It's difficult to turn down business at first, but in the long run it will be healthier for you and your studio to do so. Let's face it: some customers are just not worth having. You have the ultimate say in how you spend your time.

Earlier, I made reference to the five-second image challenge, which follows. While it takes only five sec-

**FACING PAGE**—How many weddings do you need to book to achieve your financial and personal goals?

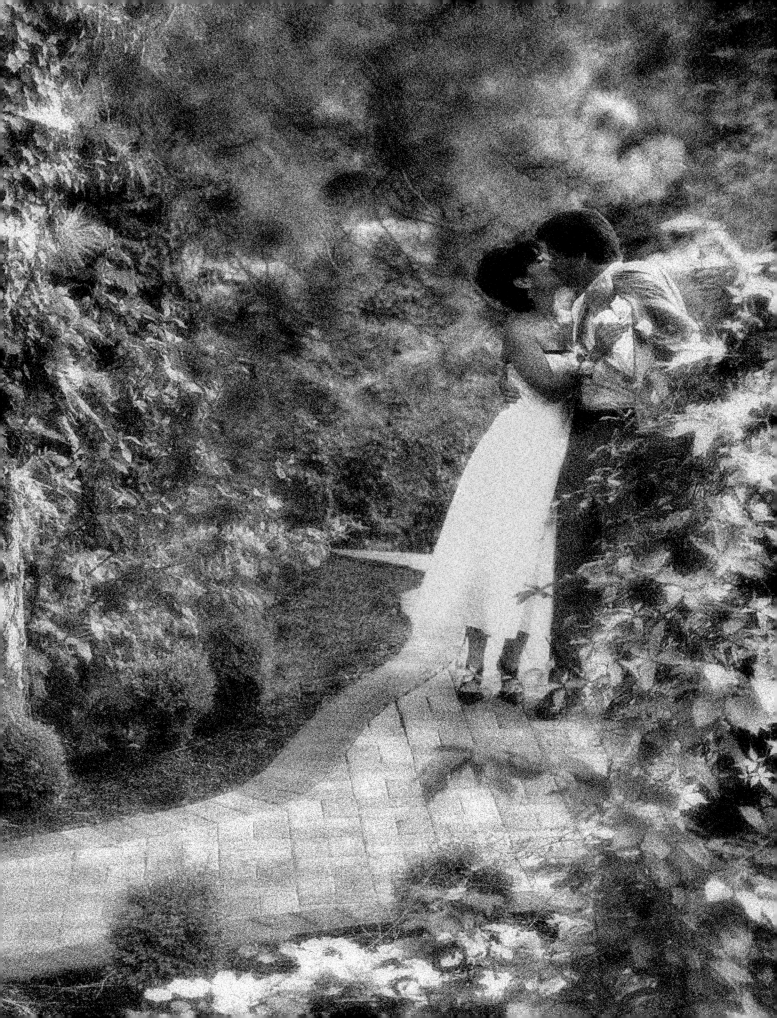

onds for clients to form an opinion of your business, learning to see what they see and to enhance those impressions will take a little more time.

So, what do clients experience when they pick up your literature, pull into your driveway, and enter your studio? You're about to find out.

### ● THE FIVE-SECOND IMAGE CHALLENGE

Do you remember what it was that triggered your dislike of snakes, or spiders, or flying, or seafood, or asparagus? You may not remember a specific incident, but I'll bet you are acutely aware of your likes and dislikes. Most of those precepts, or beliefs, were embedded deep in our psyche from experiences that lasted five, ten, or maybe fifteen seconds.

For much of my life, I didn't like okra. I couldn't tell you why; I just didn't like it. I had the opportunity a few years ago to have some with a meal, and I didn't want to be rude, so I scooped up a serving and, believe it or not, I liked it! I'm sure you can think of several things in life that you don't like, but can you remember when your dislike for that thing began?

When we are exposed to people and businesses, we quickly form an opinion of them in the same way. We make mental judgments about things in our world within five seconds of seeing, feeling, hearing, smelling, or tasting something. That judgment is filed away in our subconscience, and it colors our experiences and can affect future decisions. In business, those judgments can spell future success or ultimate failure.

In today's challenging world of professional photography, the old saying "first impressions make lasting impressions" is more important than ever! Our first perceptions are always the strongest and tend to stick with us the longest. Perception *is* reality. If you want to be viewed as a professional, you must look and behave like one. If you meet with clients for a wedding consultation or a portrait viewing, then hand them a 25¢ pen to fill out paperwork and

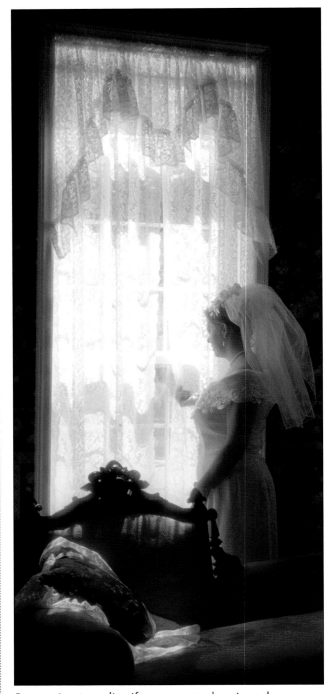

Perception *is* reality. If you want to be viewed as a professional, you must look and behave like one.

expect them to spend $5,000, you've got another thing coming. Something as simple as a pen will influence your client's perceptions of your business. If you are the $199-type of wedding photographer, then a 25¢ pen will be sufficient, but if you have big-

ger fish to fry, you need to make sure that every last detail spells quality.

Are you making the best possible first impression on your potential customers, or is there room for improvement? It has been said that the sales process ends when the client writes you a check. Well, everything that happens up to that point determines how big that check will be. That's where the quality of your image creation and marketing comes in. The better job you can do with building a strong image in the mind of your customers, the higher the value your products and services will have—and the bigger the checks will become!

Ready? Let's get to work!

**Step 1: The Image Inventory.** Before you can take a look into your business with an open and objective frame of mind, you'll want to determine how other top-notch businesses handle this issue. Take a couple of hours on a Saturday or Sunday afternoon, and go to the local mall where the elite stores like Nordstrom, The Bon Marché, Pier 1 Imports, The Sharper Image, and Ralph Lauren are located. I want you to take a notepad along so you can write down anything that strikes your fancy. Notice their signage, the colors and fonts in their logo, the smells as you walk in the front door, the overhead music that's playing, the way they have their displays organized, etc. Colors and smells affect our emotions in a very big way, and all play a key role is the value we attached to the things we observe.

Once you have a good handle on your environment, take a look at the people who are shopping there. What type of clothes are they wearing? What style of shoes do they have on? How is their hair styled? What's the age range? Take note of the color of the women's purses and the brand of the men's jeans. What car models are parked in the lot, and what colors seem to be the most popular? Write down anything you can identify about these customers. If you see something in one of these businesses that will work great for you, write it down! Stop by a nice art gallery or a fine furniture store, or maybe stop into one of the upscale photography studios in your area. Make the same mental notes about what you observe there. Plenty of great marketing ideas can be found if we take the time to look at the world around us.

After spending a couple of hours working your way through several of the top-notch stores, drive over to the local department store—whether it's Wal-Mart, Kmart, or the local five-and-dime. Observe the variables that you noticed in the first stage of this experience. Examine the signage and the cars in the lot. What impressions do you get from looking at the outside of their buildings?

When you walk in the front door, do you get the same sense of quality and value? What about the people shopping there—do they have the same style of shoes, purses, and jeans? Walk around the store a bit, and get a real good sense of who it is they want to attract into their building. It won't take you long to grasp what the marketing plan is of the big discount stores—high volume, low price, load 'em up, move 'em in, move 'em out, Yee Haw!

What does your perfect client look like? Is it someone who shops at Ralph Lauren and pays with a Discover Card, someone who shops at the warehouse stores, or is it a combination of the two? Remember there is a difference between the type of client you may have today and the client you want for tomorrow. It's all part of knowing what you want out of your life and business and having a clear vision of your future.

*Are you making the best possible first impression?*

Once step 1 is complete, go back to your studio and spend a few minutes reviewing these observations. That sharp pain you feel in your brain will only be temporary! It will go away as you begin to view the world through the eyes of your ideal client and gain a fresh understanding of the way perceptions are created.

Once you've completed this exercise, you will undoubtedly have an enhanced sense of your surroundings and will begin to see the world just a little bit differently than you did before. This is a good thing! The goal of this entire process is to learn to see the world and your studio the way a prospective client sees it.

**Step 2. The Physical Inventory.** Now it's time to make the same observations about your own business. The question I want you to keep in the front of your mind through this entire process is, Who is my perfect client? Determine whether you want to cater to old school, new school, high-end, or low-end clients, or if you prefer to attract clients that lie somewhere in between. You need to know who your perfect client is in order to critique the dynamics of your image.

Through this process, try to see your studio through the eyes of your ideal client. Remember that everything a potential customer observes about your business in the first five seconds will affect what they are willing to pay for your products and services. We're talking about perceived value. The higher the perceived value you have to your clients, the more you can charge, the more referrals you'll get, the more sessions you can shoot, and the more time off you will have to do the things in life that are most important to you!

To begin the physical inventory, first consider the outside of your entire studio, whether you operate out of your home or have a retail location. As you go through this process, it's important that you write down everything you notice. I suggest you create two columns. In the first column, you can note issues that can be taken care of rather easily, like raking leaves or washing a window. In the second column, you can list those things that may require a financial investment or a large amount of time, like painting the fence or getting new furniture for your gallery.

As you stand outside and observe your business, do you see weeds on the side of the driveway that need to be pulled out? What about your fence? Is it in good shape, or could it use a couple of nails and a fresh coat of paint? How does the paint look around the building? Does it look fresh and crisp? Are the shrubs and bushes properly trimmed and groomed?

Are your flower baskets overflowing with weeds and dead flowers? Do you deadhead your flowers on a regular basis? Is your lawn mown on a particular day each week, and is any necessary maintenance is performed? Are there weeds growing up in the cracks, and are there cigarette butts or bubble gum wrappers in visible sight? Are there dead leaves scattered all over the ground?

What about the windows? Are they consistently washed, or can you see fingerprints and dirt on them?

Note that having a top-quality image means that some things go unnoticed. If a window is clean, you don't notice its lack of grime, do you? But you will definitely notice if they are covered in finger prints and smudges. Or if the grass is neatly mowed, you don't notice that it *doesn't* need mowing. Keep an open mind as you go through this process.

Now, we are going to walk inside your studio for the first time. Is your entryway inviting? Have you

Try to see your studio through the eyes of your ideal client.

hung high-quality signs that clearly list your business hours, or do you use a dry erase board?

As you walk in, how does the appearance of your studio make you feel? Does it give you that *wow* feeling? Does that feeling match the image you want to build? What smells do you notice? Are they fresh and clean or old and musty? What part of your studio do you see first? Does it look clean and organized? When people walk into your gallery, you should tell them everything you want them to know about you through the work displayed on the walls, the fragrance in the air, the style of the furniture, and the general overall feeling they get within that first five seconds! Not everybody has top-of-the-line designer leather furniture and turn-of-the century Victorian artwork in their studio, but we each need to make sure that what we *do* have supports the image we want to convey and appeals to the type of client we want to do business with.

Now, head toward your sales area or projection room. Do you display large prints on the walls or 8x10-inch prints? People can only buy what they see, and if all you show them are 8x10s, how can you expect them to invest in a 30x40-inch canvas portrait? It's not likely to happen! When I first opened my studio, I didn't have much of a budget for large

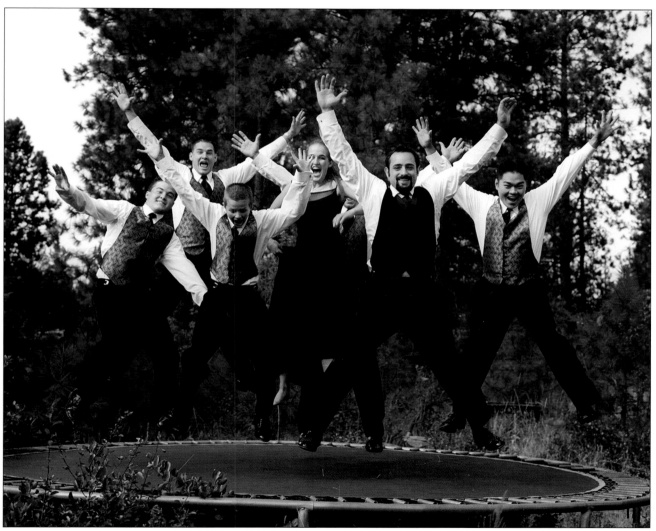

My image tells prospective clients that I am willing to have some fun and try something out of the ordinary. This is just the type of client I want, and it's the exact type of client I attract!

prints, so I went hog wild and displayed lots of 11x14s and 16x20s. I had them everywhere! Guess what I sold a lot of? If you want to sell big, you must show big!

What about your sample albums? Are the pages routinely dusted and wiped down? Are all the prints inside still correctly mounted, or are a couple of them in need of repositioning? Are your shelves and countertops wiped down on a regular basis? Do you have candles located around your studio that add fragrance to the air? When a client walks into your studio for the first time, all of their senses are on high alert, and you want to make sure you give them an enjoyable olfactory experience!

Let's continue the process as we head into the camera room. This is a difficult one; we all get a bit lazy when it comes to maintaining our camera rooms. I have a tendency to put all of my equipment, filters, and film on one shelf, so after a while it begins to look very cluttered and disorganized. I force myself at the end of each shooting day to put everything back where it belongs. It only takes me a couple of minutes. How is your camera room organized? Are the backgrounds neatly folded, or are they thrown into a corner because you don't have time to fold them during a session? How about your miscellaneous equipment shelf? If it's in the line of sight of your customers, how does it look to them? Could it benefit from a little time spent in organization and rearranging?

Take the same steps with your dressing rooms, public bathrooms, and the hallways that lead to them. If you have a portrait park like I do, or even a small outdoor shooting area, take notice of the same things you noticed about the front of your building—the grass, the

Anything you can do to make that client enjoy themselves even just a little bit more is worth doing.

shrubs, the bushes, the trees, the flowers. When a client walks outside of your studio for the very first time, are they in awe with how beautiful everything is, or could your property use a little TLC? The image of your entire business is like one big apple pie, and the things we have talked about are the vital ingredients we need to make the best apple pie we can!

When clients arrive at your studio, do you offer them some sort of beverage, like a soft drink, a glass of wine, or a cold beer? Do you have snacks available in case they want something to munch on? I know several photographers who bake a fresh batch of chocolate chip cookies every single day, and you can smell them as soon as you get out of your car. That kind of attention to detail makes a person feel good inside! Anything you can do to make that client enjoy themselves even just a little bit more is worth doing. If they enjoy themselves during their time with you, they will be happier with their portraits and will spend more money and send more referrals!

**Step 3. The Marketing Inventory.** You'll need to sit down to complete this challenge! Grab a good cup of coffee, then gather every piece of literature you have. This includes things like business cards, price lists, brochures, wedding information, reorder forms, clothing tip sheets, coupons, contracts, direct mail pieces, newspaper ads, yellow pages ads, bridal fair ads—anything you hand out, mail out, or stuff into something!

Your marketing literature makes a significant impact on your clients. It factors heavily into the client's perception of the position you occupy in the market. The quality of the paper it's printed on, the font selection, the quality of the ink, the color of the paper stock, the way you present it to your customers—it's all part of that apple pie! Do you just

*Invest some time and money to create a unique look for your business*

hand your clients a piece of paper with your wedding or portrait prices on it, or do you package your price list in an elegant envelope with gold-foil lettering, finished with a gold seal? Perception, perception, perception!

If you are not exactly sure how to improve on what you already have, take a look at some of your competitors' literature and at some marketing materials from other industries. Your life insurance policy, the Franklin Mint plate sales flyers, the welcome kit from you local chamber of commerce, sales flyers you get in the mail, and wedding invitations from your supply house may prove to be a good source of inspiration.

These are all things that can give you fresh ideas on how to improve your marketing literature and your image. You can do anything you want if you just open your mind up to new and innovative ideas from outside of the box. I challenge you to invest some time and money to create a unique look for your business that is unequalled in your market, one that separates you from the rest of the pack!

There are a few other very simple ways in which you can enhance your image and create greater value for your products and services. First, say thank you. Any opportunity you have to say those two little magic words should be treasured and taken advantage of. We should never pass on a chance to make our clients feel special and appreciated. This alone can make all the difference in the world in your business this year! Say thank you, and mean it! Say it a lot! Send thank-you notes within twenty-four hours of a client's visit, or call them within twenty-four hours after they pick up the final order to make sure everything is okay. You have other occasions to touch their lives during the year also; you can send a card on their birthday or anniversary, to congratulate

## PHOTOGRAPHER'S PRAYER

I have been given the gift of SIGHT, the gift to truly see a feeling, a personality.

I have been given the art of CARING. To know each one is special . . . exactly as they are.

I have been given a very special TALENT. To take the magic of an individual smile and capture it forever.

I have been given the ABILITY to hold memories for others, in turn, to hold dear.

I have been given the PRIVILEGE to share in the more precious times of another's life, in laughter, joy, and tears.

Please give me the RESPECT for others at all times to let them know how truly special they are.

Please give me the KNOWLEDGE to not only grow in technical expertise, but also in character.

Please give me the STRENGTH not to let life's problems overwhelm me and become larger than they are.

And above all, let me keep a LOVE of life, more than my heart can hold; so that by sharing what has been given me, I will be the BEST I CAN BE!

—*Author unknown*

them on a job promotion or awards they receive, or to wish them a happy holiday. There's no reason why you can't send a card for no particular reason whatsoever, for that matter! You will be amazed how much goodwill you can create from simple gestures like this.

If I lived in the big city, I would probably have to have a completely different type of marketing plan than I do today. But we each build our own business, our image, and our marketing programs around who we are as human beings. Before clients even get a look at our price list, they know who we are and what we can do for them. Once we have them hooked on our image, our prices become secondary!

That's it for the image challenge! How did you do? You probably have a few pages of projects and things to do in and around the studio over the next several weeks and months. Don't feel overwhelmed by the amount of stuff you wrote down. It just shows you have lots of potential for future growth and

improvement! To make your to-do list a bit more manageable, you can break it up into a weekly task list. Get your staff and your family involved, have a neighborhood work party, and throw everyone a barbeque, complete with beverages, as their payment! Have some fun with it, and get other people excited about getting involved. Life is meant to be enjoyed, whether we are playing or working!

There are two kinds of service: great and bad. Mediocrity makes little or no impression on most people. Make it your goal to go above and beyond the call of duty when it comes to providing gold-medal, top-notch, number-one-rated customer service. This is the best way to create customers for life and to keep the referral highway filled with traffic! And remember . . . referrals are free!

The most difficult part of the wonderful world of marketing lies in learning to understand the way the world around us works. We need to look into the way perceptions are created about you and by you,

how value and perceived value are ultimately controlled by you, and how the entire process begins with the creative juices only you can provide. Your brainstorming can lead to incredible breakthroughs for your studio—and your life. Without brainstorming, we wouldn't have things like ice cream cones—or toilet paper!

I want to share a story about the vice president of marketing of a Fortune 500 company who had an innovative idea for a new product. The rest of the board had their reservations about his idea, but he believed so firmly in his idea that he convinced the other members to grant him permission to proceed with the project. A few months later, when the project had completely and utterly failed to the tune of about $3,000,000, the VP began clearing out his office. When the president of the company walked in, he asked the VP, "Where are you going?" The VP responded, "I'm clearing out all my personal things and going home. I just made a huge mistake that cost your company $3,000,000. I assumed I was fired!" "Are you crazy?" the president said, "I just invested $3,000,000 in your education!"

Every idea you come up with isn't going to be a home run, and many will probably end up being strikeouts. But there is nothing worse in this world than never even swinging the bat! Risk is part of success, and those who are willing to stick their necks out each and every day—like you do—are the true heroes of our industry. You cannot experience the joy of discovering new lands if you never risk losing sight of the shore.

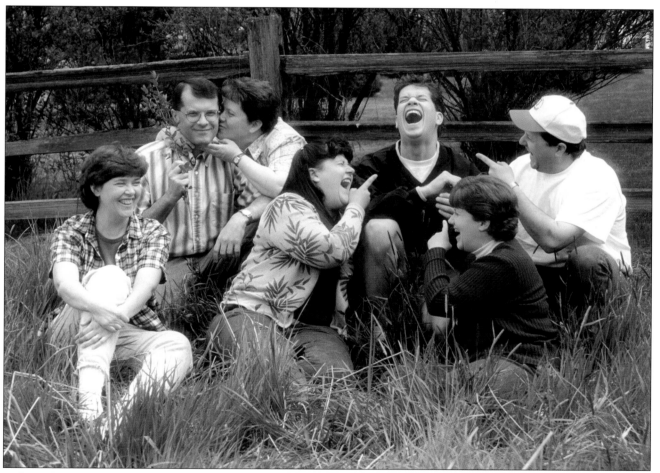

Before clients even get a look at our price list, they know who we are and what we can do for them. Once we have them hooked on our image, our prices become secondary!

## FOCUS ON . . .

## JEFF AND KATHLEEN HAWKINS

What happens when you combine the talents of one of the best photographers in the country and one of the best marketing minds in the industry, then throw in a little love for good measure? You get the dynamic duo of Jeff and Kathleen Hawkins!

Jeff has been a professional photographer for over twenty years. He has photographed many celebrities, including Ed McMahon, Regis Philbin, Reba McIntyre, Billy Ray Cyrus, Mary Kay, Charlie Daniels, John Anderson, John Michael Montgomery, Marty Stuart, and Shaquille O'Neal.

Kathleen holds a Masters in Business Administration and spent nearly a decade teaching marketing and business courses at a local university.

Together, they are a very dynamic team who have become the epitome of success. They are also the team behind several successful books, including *Professional Marketing and Selling Techniques for Wedding Photographers* (from Amherst Media®).

For more information on their educational materials and workshops, visit www.jeffhawkins.com or www.kathleenhawkins.com.

**Mitche: What is the biggest challenge that our industry will face in the coming years?**

*Kathleen:* I think one of the biggest will be workflow management, and learning how to control where you spend your time. There is also an influx of really new photographers popping up all over the place, so it's important that you understand who your market is so you can effectively compete with these amateur photographers.

*Jeff:* Also, the overwhelming influx of products, software, and equipment onto the market. It gets to be too much for photographers to absorb. You can easily get caught up in the trap of using all this stuff! You need to identify the products that are going to work for you and your business, and stick with that! There are always going to be new toys that are going to come out, but you need to focus.

Another challenge is that all of the consumers have access to the same types of technology that professionals do, and we have to have something that separates us from the amateurs. They have access to equipment that will do a phenomenal job. What we have to do as professionals is separate ourselves from those amateurs, and position ourselves as photographic artists.

**Who is your perfect client?**

*Kathleen:* Anybody who has a sign that reads "Make me feel special!"

**What are the most important attributes of a Power Marketer?**

*Kathleen:* The ability to apply critical thinking skills. If you understand the dynamic that all people want to be made to feel special, and then learn to have interpersonal strength to deal with them, you have just accomplished the first step in becoming a Power Marketer.

*Jeff:* And I think you also need to have the ability to

identify personality types, what type of person are you talking to, what are they interested in, and really listening to what they have to say. You can then provide them the product that will help them get what they are looking for.

There are tons of different products that we can offer them, and it's our job as good marketers to educate them so they can make the right decision.

**What is most important to you from a "life" standpoint, and how does that come into play in your business?**

*Kathleen:* Keeping your priorities in perspective. Our faith first, then our family, then our career third. Making sure that we are working our business instead of letting our business work us.

*Jeff:* I think also, that when you own a photography company, it's not a job, it's a business. If you have a job, you work for somebody else.

It may mean working a lot of extra hours, but I don't think it's really considered work when you are the owner. I think that's important for people to understand.

**How do you balance your personal and your professional lives, with everything you have going on?**

*Kathleen:* One of the things we do is have "date night" on Friday nights! It used to be on Wednesday, then *The West Wing* came along, so we changed it to Fridays nights! That keeps us focused on what is really important in our life together.

We believe in working less and getting paid for our talents, so that we can give our family the things they need and have the time needed to maintain our faith. We understand the importance of giving back to oth-

ers and to the industry and take time for that, but also know how important it is to take time out for each other, our family, and our education. These goals and proper prioritizing have helped us stay ahead of the changes in the industry and continues to provide us with the personal and professional growth we desire.

**So I take it you really like *The West Wing*?**

*Kathleen: Yes!* I will also have you know that I have an application on my desk for *The Apprentice,* and I'm going to apply! I just have to! I love that show!

> "These goals and proper prioritizing have helped us stay ahead."

**Tell me about your family life.**

*Jeff:* I have two daughters, aged nineteen and sixteen. And we are now looking into the adoption process; it's very exciting for both of us to think about having a baby.

*Kathleen:* You just want me to quit telling you what to do and start telling a baby what to do!

*Jeff:* That way, I can go out and ride my Harley more!

**What is your hook?**

*Jeff:* I think what separates us is our style. We are able to use our digital technology to create more artwork for our clients. I also think that the service we offer and the products we have are unique in our market.

*Kathleen:* Jeff created a phrase, and he calls himself a "photo-relationist." It's basically a PR concept, and when we get a new customer, we look at them as customers for life! We want to photograph their wedding, their children, their family, all of it.

*Jeff:* In essence, we are documenting and capturing relationships, and that's the way we approach our marketing.

**Have you had a marketing campaign that has been an absolute home run?**

*Jeff:* I would have to say the Lifetime Portrait Credit. It was started because we wanted to establish and develop relationships with our customers, and to continue them for the rest of their lives. They basically get free portrait sessions for the rest of their life. They don't have to pay a session fee, they only pay for what they purchase.

*Kathleen:* When a client hires us to photograph their wedding, they automatically become a member of the program. It has not only separated us from the industry, it's done much more!

**What about your least successful?**

*Kathleen:* We just did Halloween portraits last year. There was this park where businesses would set up a booth, and we thought it would be a great way to let people know that we did children's and family portraits by offering them affordable Halloween photos. The little trick-or-treaters would come around to each booth, and I think we each had to have 50,000 pieces of candy. So, I went out and spent $1000 on candy alone!

People just didn't want to have photos of their kids in Halloween costumes! We did get one good client out of it, and if he comes back for a second session, maybe we will get back our initial investment!

*Jeff:* We went out and bought hay and all kinds of nice set items, but the interest just wasn't there. Needless to say, we won't be doing that again!

**When you aren't working, what do you do for fun, besides having a "date night"?**

*Kathleen:* I go to the spa!

*Jeff:* I ride my Harley! I have a '98 Fatboy that's been totally customized. That was a real passion of mine for the last several years, to customize it and trick it out.

**Are you a serious rider, or do you ride just for fun?**

*Kathleen:* He's pretty serious about it!

**Favorite movie or show?**

*Jeff:* For her, it would have to be any "chick-flick." I've seen a lot of movies that I like. And we absolutely love *The West Wing* and *The Apprentice.*

*Kathleen: Legally Blonde* was really good recently, and hands down on what Jeff said!

> "If you know how to delegate, you can be successful doing a lot of different things."

**Favorite food?**

*Jeff:* Sushi.

*Kathleen:* Sushi.

**How sweet is that?**

**Favorite book?**

*Kathleen:* Any type of motivational book. I'm a success book junkie! I love them!

*Jeff:* I'm not one to sit down and read much. I don't have enough time for that.

**Who are your biggest inspirations?**

*Kathleen:* I would have to say Jackie Applebaum, the owner of EventPix. She has so much going on at any given moment that it used to make me second-guess whether or not I was focused enough, because I wasn't as organized as her. Then, one time I saw this woman with three phones in her ears, and we thought to ourselves, "How many businesses can we open, and what can we do?" If you know how to delegate and you know how to manage, you can be successful doing a lot of different things.

Every time we have any contact with her, we come back and we do something to improve our business!

*Jeff:* I would have to agree with Kathleen. She has really inspired us both!

**Do you have a favorite saying?**

*Kathleen:* Just because you can, doesn't mean you should! Just because you can be a lab, doesn't mean you should be a lab. Just because you can build a website, doesn't mean you should build a website. **I love it!**

# 7.
# SPECIAL REPORT!
# MITCHE'S TWELVE-STEP PROGRAM

Would you like to reinvent the way your studio operates? Although you are searching for ways to take your business to the next level of success and profitability, are you met with frustration? If you truly devote yourself to accomplishing the following twelve steps over the next seven days, I guarantee you will reenergize and invigorate your creativity and will give yourself a whole new perspective! I will tell you right now it won't be easy, but if you are diligent with your follow-through, your life will change forever!

If being an entrepreneur were easy, everyone would be doing it! It takes a very special person to keep their nose to the grindstone each and every day, through good and bad times. Seven days is long enough to only *begin* to create new habits, so upon reviewing this chapter, your goal should be to make these steps part of your everyday routine. It's very easy for us to get caught up in the day-to-day details of running our businesses instead of designing our lives. I challenge you to take this project seriously; you will reap the rewards for doing so!

**1. Make a list of your personal and professional goals for the next twelve months.** This is perhaps the easiest task on the entire list! Grab yourself a good cup of coffee and a notepad, and spend some quality time writing down what your goals are for the next twelve months. First, list your personal goals, then write down your professional goals. Once you figure out what you want out of your life, the rest will come easy!

Do you want to take a vacation—or two or three—this year? Do you have your eye on a special boat or a set of golf clubs? How about your garden? Would you like to spend more time cultivating it or working in the yard? What about other hobbies you may have, but haven't made time for recently? If it's important to you, then you should make time in your schedule to read, or write, or paint, or play with the family dog. Having a strong marketing plan will allow you to be more productive in your working hours, which will allow you to take more time off to do the things in life that are important to you. It all goes hand in hand!

If being an entrepreneur were easy, everyone would be doing it! It takes a very special person to keep their nose to the grindstone each and every day, through good and bad times.

**2. Set aside fifteen minutes a day for the next seven days to study in the field of marketing, and brainstorm about your business.** This is very simple. Grab a stack of 3x5-inch cards and spend some quality time with yourself getting the creative juices flowing! It's easy to get carried away with spending all of our time playing with our new toys or reading up on the latest digital camera, or fiddling with Photoshop. We call that the *substance* of the business. For this exercise, we are talking about the *essence* of your studio. Where do you want to be in six months? Twelve months? Two years? Five years?

We have so many resources available to us, whether it be videotapes, magazines, books, cassette tapes, or newsletters; and the tips they contain are ours for the taking. Give yourself some time to work through the materials—as well as to accomplish any other business-related tasks you've been putting off. Make sure that you are working in a place where you won't be interrupted or distracted. Power Marketers are not born, they are developed; and by spending just fifteen minutes a day immersed in learning and brainstorming, you will begin to create positive habits that will stick with you for the rest of your life! Once you come up with an idea, *write it down!* After you put it on paper, it will be much easier to expand the idea and develop it into creative breakthroughs!

**3. Take the Five-Second Image Challenge to learn how prospective clients see your business.** (See pages 100–107.) Working on any problems you identify will only serve to strengthen your business.

**4. Add a sales flyer, coupon, and/or reorder form to every item that leaves your studio.** Anything that leaves your studio—portrait orders, state-

ments, bulk mail, dance packages, sports team packages, wedding albums—should have some sort of promotional piece included. If we don't give our current customers the opportunity to make additional purchases, we are leaving a tremendous amount of money on the table. It needs to be taken from your clients' pockets and put into yours, where it rightfully belongs!

The most neglected and under-utilized market we have is comprised of our current clients. They already know about us, have done business with us, have written us a check, and more than likely have told their friends/families about us. Then why not maximize this potential and make sure our studio is in the forefront of their minds? When you do, you will be surprised at the response you will get!

**5. Track each and every call, walk-in, and inquiry for the next seven days.** This project can be done simply with a piece of notebook paper and a pen. First, create columns across the top of the page that list the prospective client's referral source, and then create a column along the left side of the page for the prospective customer's name and date of inquiry (see the chart on page 66). When somebody calls or walks into your studio for the first time, ask them how they heard about you. Was it via a referral from a satisfied customer, another photographer in town, or from the local florist, church, or yellow pages add—or maybe an event facility, family member, or neighbor?

This will do two things: First, you will find out what forms of marketing are working for you, and second, you will find out what is *not!* If you are spending $200 per month on a yellow pages ad, and you receive two calls a month, you can probably find a better use for your $200. Tracking your inquiries will show you where your efforts are returning the best results and which need to be reworked—or dropped altogether!

**6. Make it a goal to add on at least one item onto each order for the next seven days.** This doesn't have to be a big item, maybe even only one more 4x5-inch print or a two-way portfolio or an additional unit of gift wallets. If you consistently work on adding just one more item to each of your orders, it will add up to a substantial amount of money over time! This can be done in a couple of ways. You can either add some extra value into your packages that gives your customers the "incentive" to move up to the next package on their own, or you can create a unique product that can be added on at the end of the sales process for a nominal amount. If you let the way your packages are built do most of the work for you, there will be little need for you to have to force-feed another item down your clients' throats! Since we are artists, it's sometimes difficult to sell our own work. Let your packaging work for you!

**7. Spend at least thirty minutes this week talking with at least two other photographers in your area.** Most of us are friends with several other photographers in the industry, but how do you feel about sharing your knowledge and expertise with other photographers in your market? We need to realize that we all are charged with the responsibility of educating the general public about the benefits of having professional portraits done, and to that extent we are all on the same team.

You don't have to give away any trade secrets, and neither do they, but sharing ideas is one of the most powerful ways to educate ourselves. Whether you get together for a cup of coffee to talk about programs you are both working on, or make a plan to refer clients back and forth to each other, or play a round

The most neglected market we have is comprised of our current clients.

of golf at the local country club, make it a goal to invest some time in the next week to develop a stronger relationship with other photographers in your market.

**8. Develop a direct mail piece that you can send to every person in your database. The mail piece should feature your hook, plus an offer.** One of the most neglected markets we have is our current customer base. You have already spent time, money, and effort to recruit them into the fold; why not keep them there? There are several resources that teach you how to construct and develop a direct mail piece that is guaranteed to create excitement and produce results. You want to let them know what your unique "hook" is and why they should spend their hard-earned money with you instead of some-

one else. There are books, tapes, videos, and newsletters that will take you step by step through the process.

You will want to make sure that you (1) give them a compelling reason to do business with you again; (2) give them an offer they can't refuse; and (3) give them a short deadline in which to respond to the offer (no more than two weeks from the date of the mailing). Once you have created your piece, you will need to create a list of people to send it to. If you have been around for a number of years, you may want to scale your list down to include clients you've worked with in the last twelve to twenty-four months. These people already know the quality of your work and the level of your service, and will be more likely to respond to a promotion like this than someone who knows nothing about you. Whatever the response is on the first mailing, you will

If you consistently work on adding just one more item to each of your orders, it will add up to a substantial amount of money over time!

achieve approximately the same response with a second mailing, and a very similar result from a third mailing. Once is nice, twice is better, and three times is a charm! This will all depend on the time you want to commit to the promotion, the amount of dollars you want to invest, and the size of your customer base.

**9. Spend thirty minutes this week talking with other vendors in your market.** Whether you photograph weddings, seniors, families, children, or llamas, you have undoubtedly developed a network of relationships with other vendors in your industry. It could be the clothing store where your high school

Having a sense of humor is vital to our ability to overcome those feelings and to making sure we maintain a proper perspective of our life.

seniors purchase their clothes, a tuxedo shop where the groomsmen from your weddings rent their tuxedos, a local hospital where babies are delivered, a florist, an event facility, a jeweler, or a llama farmer. In any case, it is vital that you have a good working relationship with each of them.

This is perhaps the single most powerful form of marketing you can develop and invest time in. If you make it a goal to have at least one sit-down meeting with one vendor per week, you will steadily grow your referral network by leaps and bounds over time!

**10. Take at least thirty minutes per day to take a walk on the lighter side of life!** Did you know stress is the number one killer in the United States? When things get difficult in life, we get overwhelmed with that feeling of uneasiness. Most stress is caused by change, and our world is overflowing with change every day! Having a sense of humor is vital to our ability to overcome those feelings and to making sure we maintain a proper perspective of our life. It's easy to forget about the little things that make us happy—holding a baby, going for a walk, watching a good sitcom or movie, getting a letter from a good friend, hitting a great drive off the tee, or even something as simple as watching the sunset on a warm evening. If we can figure out a way to keep it light in the face of stress and change, it will keep us healthier, make us happier, and above all give a more fulfilling feeling about ourselves!

Did you know that when you laugh so hard your cheeks hurt and your stomach aches, your brain releases a natural painkiller called endorphin that gives us a general sense of well-being? Can you remember the last time you

laughed so hard you had tears in your eyes? If not, it's time to search out some good laughter!

**11. Make sure that your website address is listed on each and every piece of literature that leaves your studio.** The World Wide Web is here to stay! By now, most studios have some sort of presence on the Internet. In today's fast-paced society, we are becoming more and more dependent on the Internet when it comes to getting information on the world around us, communicating with customers, and reaching potential customers. If you don't already have a website, getting one should be one of your top priorities! Your competitors are there, and you need to be there as well!

An Internet presence allows people to learn about you, see a gallery of your work, and communicate with you at their convenience—twenty-four hours a day, seven days a week, 365 days per year. You can add staff bios on your website, educate

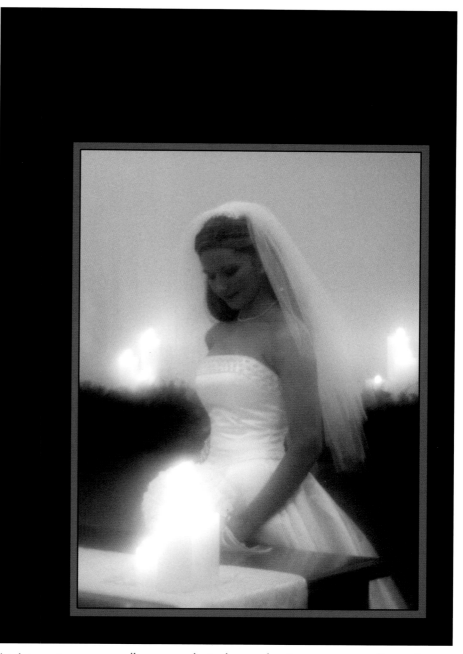

An Internet presence allows people to learn about you, see a gallery of your work, and communicate with you at their convenience—twenty-four hours a day.

people on the importance on different aspects of photography, and even list your awards and accomplishments. But perhaps the biggest reason for being on the Internet is that your wedding and portrait clients can now view and purchase your work from the privacy of their homes without ever stepping foot inside your studio! This allows us to not only create additional sales from each wedding and session, but it also exposes the entire world to our work! Geographically speaking, families and friends are becoming increasingly more spread out, and what better way to bring them together than with a personal website of images! Is your website and e-mail address listed on every piece of literature that leaves your stu-

dio? Is it listed in small print at the bottom, or is it presented boldly and distinctively?

**12. Send out a press release to every newspaper within a 100-mile radius of your studio. Keep your local papers up to date on the latest happenings in your business.** If you read your local newspaper, you will notice that there is a section devoted to news about who's getting promoted, who's won an award, what businesses are moving up, and who's moving along! You will probably also notice that the same businesses seem to get the most ink time and again. Your perceptions are correct! These are the businesses that have it figured out! If you can get other people talking about you for free, there is little or no need to pay to have people to talk about you! All you need to have is a piece of paper, a pen, and something about you or your business that the world should know about. That's it!

If you have recently won an award for your photography, hired a new employee (or promoted an existing one), expanded your camera room, attended a photography convention, or have had an article published in a trade journal, you have a legitimate reason to write a press release! Editors are constantly searching for news about the local community to publish in the paper, and there is no reason why your studio shouldn't get its fair share of column space! One of the keys to a successful marketing plan is to keep your name in front of your market as often as possible. A well-written press release can accomplish this. Keep the fax numbers next to the fax machine and get into the habit of writing at least one release every four weeks. It doesn't have to be very long—only a couple paragraphs—but it should be structured to answer the basic questions of journalism: who, what, when, where, why, and how. If you apply this simple rule, you should see your name in print before the week is out!

Well, there you have it—Mitche's twelve-step program! Are you ready to make a commitment of this magnitude? Are you willing to make the changes necessary to ensure that you are successful with this program? I didn't say it would be easy, did I?

I wish you luck!

## FOCUS ON . . .
## SKIP COHEN

Skip's career in the photo industry started at Polaroid in 1970 where, over the course of seventeen years, he held positions in research, personnel, and customer service, and was the U.S. marketing manager for Polaroid's photo-specialty dealers. In 1987, he left to take over Hasselblad USA as President/CEO and to pioneer Hasselblad University. In 1999 he helped launch an Internet photographic retail site as president of PhotoAlley.com.

Skip is now President/Chief Operating Officer of Rangefinder Publishing Inc. and has responsibility for *Rangefinder* magazine, the Wedding and Portrait Photographers International Association and Trade Show, as well as *Focus on Imaging* magazine. Two key industry fund-raisers created by Skip include the sales of Ansel Adams's Cadillac to the Coastal Hotel Group in 1991 and the sale of Ansel's Hasselblad gear to shock jock Don Imus in 1997, raising $100,000 for charity.

Skip has written two books: *The Art of Wedding Photography* (Watson-Guptill) with Bambi Cantrell and *Don's Blair's Guide to Posing and Lighting Body Parts* (Marathon Press, Inc.).

To contact Skip Cohen, please call 310-451-0090.

**Mitche: What do you feel is the biggest challenge facing our industry in the future?**
*Skip:* Keeping up with technology and reaching our target audience. We are all competing, not just against ourselves, but other businesses. If it took three times for a consumer to remember your name years ago, today it's six to eight.

Professional photographers are competing against companies like BMW or that "Zoom, Zoom, Zoom" commercial for Mazda, for example. Everyone is competing to get through the "noise" and build brand recognition.

**Describe your marketing philosophy.**
Education. It's all about being accessible to your customers and providing quality education.

**What are the most important attributes of a Power Marketer?**
Knowing your target market, without a doubt! There's a great line from a marketing consultant by the name of Ed Foreman—he said "If I can see the world through Mitche's eyes, then I can sell Mitche what Mitche buys." In order to achieve this, you need to know your client.

**What things are important to you in life, and how does your marketing come into play with those priorities?**
If you love what you are doing, you tend to do it well. You tend to have more enthusism. People accuse me of being wound a little too tight sometimes, and I laugh about it. If you look around the industry, I have always believed that if you're not having fun with what you are doing, get out and change gears. I've been very fortunate in my life, and I love what I do! I love photography, I love what great photographers are able to do, I love the magic. I've always believed that with the exception of mod-

ern medicine, there is no industry that has given the world more than photography.

If you think about it, everything from capturing a wedding to documenting the violation of human rights is captured by a photographer. If it wasn't for photography, what would 9/11 look like? It would have been a bunch of pencil sketches. Or for someone's wedding we would have drawings of a wedding cake. Photographers tell the story, good or bad. If you don't love what you are doing, make a change. I happen to love what I do so much that people accuse me of having an overindulged zest for life! Basically, it's a "work hard, play hard" approach.

**How do you balance your personal and professional life?**
Sometimes very well, sometimes lousy! There's a very thin line between your personal and professional life if you love what you are doing, because your professional life becomes your hobby.

**When you are not working, what do you do for fun?**
Scuba diving is probably my ultimate passion. I think it has a lot to do with sitting on the bottom of the ocean where no phones can ring, with no faxes to deal with. It's a total departure for me. In the first five years I was diving, I logged around 300 dives. Both of my kids are certified, and we've had some pretty incredible adventures.

**Tell me about your family.**
I have two kids, aged thirty-one and twenty-seven, and I've always had an absolute ball with them. I'm very close to both of them. Debbie and I have been married for thirty-three years. When I was a kid, if somebody asked me what I wanted to be when I grew up the answer was always "a Dad." Now I'm a third-generation "Papa" with two grandsons, and it just keeps getting better.

**What do you feel has been most successful marketing program you have ever done?**
The most current would be the growth of *Rangefinder* magazine and WPPI, but it's been a team effort. Our readers and photographers said they wanted more from an educational and programming standpoint. We've done our best to listen, and the growth of both has been tremendous. The most successful "solo" programs both involved Ansel Adams and were fund-raisers. The first was when Hasselblad sold his 1977 Cadillac to raise money for Photographers + Friends United Against AIDS, the second was selling his camera gear with the proceeds going to the Elizabeth Glazer Pediatric AIDS Foundation.

**Mitche: What about your least successful attempt?**
Actually, the least successful became one of the most successful. I'm talking about Hasselblad University. I had an idea in the early 1990s for a four-day weekend with about ten different programs, and the student could pick six of those classes to attend. We had the best of the best when it came to the instructor team. The problem is, we didn't realize at the time that very few people could afford Santa Barbara, CA during the last weekend of the summer! You couldn't get a room for under $300 a night right before Labor Day! The program was a total and dismal failure. We had to cancel it. We built it and nobody came, but the logo won an award!

After that, I hired Tony Corbell to come to work at Hasselblad, and we decided to figure out a better

**"If you don't love what you are doing, make a change."**

way to launch Hasselblad University. The next year we went out with a full ten-city tour that was an absolute blowout! We had just done it the wrong way to begin with.

**What's your favorite movie?**
*Braveheart, Gladiator,* anything *Star Wars, Indiana Jones* . . . I just want to be entertained. Plus, *Star Wars* was a big piece of my son's life growing up. We had the whole galaxy built in our basement when he was little. My wife recently dragged me off kicking and screaming to see *Love Actually.* I hate to admit it, but I really enjoyed it. I found myself wanting another half dozen characters.

**Favorite food?**
Lobster and steamers.

> **"The next year we went out with a full ten-city tour that was an absolute blowout!"**

**Together?**
Spoken like a kid from Idaho—of course. Besides, do I look like a guy who has any food that isn't his favorite?

**Favorite book?**
I don't really have one. I like totally brain-dead mysteries, easy-to-read-on-a-plane type of books.

**Who are your biggest inspirations?**
My Dad, who was also best man at my wedding and is still my best buddy. I feel pretty lucky to be in my 50s and still be able to drag Dad off to a convention. On the public side of life, JFK and Bobby Kennedy. On the photographic side of life, I'm the luckiest guy in the industry—my friends keep me focused.

# CONCLUSION

When it's all said and done, the only thing that will separate us from the rest of the pack will be the amount of passion we invested into our life—our family, our hobbies, ourselves, and our work. It has been said many times that if you don't absolutely love what you do for a living, do something else! Life is way too short to not do the things that bring you happiness and a sense of fulfillment.

You are one of the fortunate few who have been blessed with a passion for the wonderful world of photography, and hopefully you wake up each and every day full of excitement and looking forward to going to work! My dream is that this book has rekin-dled, or sparked for the very first time, a vigorous desire to bring that same kind of passion and conviction to your marketing.

If you are committed to making the necessary changes that are required to drive your business to higher and higher levels, then you will be well on your way to becoming a Power Marketer. The road to success is definitely less traveled, but well worth the extra effort! Your new-found enthusiasm will allow your creativity to flow like never before, and will catapult your life to new heights.

Good luck, and Power Selling!

# INDEX

**A**

Advertising, 60
Appearance of studio, 29, 58, 85

**B**

Borrowing ideas, 83, 96–97
Box, Doug, 88–92
Brainstorming, 28–30
Branding, 22–23, 43, 49
Bridal fairs, 67, 81, 85, 90, 105
Brochures, 57–58, 97, 105
Budget, 19
Business cards, 57–58, 97, 105

**C**

Cantrell, Bambi, 46–51
Catalogs, 9–10, 57–58, 97
Category ownership, 39
Chamber of Commerce, 85
Claims, substantiating, 39
Cohen, Skip, 119–21
Competitors
    evaluating, 30–31
    standing out from, 53–56,
        *see also* Hook *and*
        Branding
    strengths and weaknesses, 29,
        31
    visiting, 31, 114–15
Complacency, 47–48
Consultations, 42
Costs, 29, 98
Country club promotion, 23
Critical thinking, 108–9
Curb appeal, 29, 58, 85

Current marketing, evaluating
    your, 18–20
Customers
    new vs. existing, 11, 37, 65–67
    perceptions of, 19, 27–28, 29,
        30, 32, 57–62, 100–103
    personality types, 109–10
    questionnaire for, 65
    testimonials from, 65
Customer service, 38, 67–69,
    105, 106

**D**

Delegating work, 42, 88
Demographic
    determining, 22, 46–47,
        55–56, 119
    positioning yourself for,
        53–56, 84–85, 98–103
Designer brands, 22–23, 47,
    49–50
Digital imaging, 7–8, 41, 46,
    70–71, 84, 85, 89–90,
    108
Direct mail, 9–10, 12, 57–58, 85,
    97, 105, 115–16
    mailing lists, 58, 67
Displays, 29, 42, 44, 67
Discipline, 42
Discounts vs. giveaways, 81

**E**

Education, importance of, 90, 119
Emotion, impact on purchase,
    38, 81

Employees, 23, 29, 37
Exhibits, 74

**F**

Failed efforts, 12, 19, 44, 51–52,
    67, 81–82, 107, 110
Fashion magazines, 47–48
Ferro, Deborah Lynn, 84–87
Ferro, Rick, 84–87
First impressions, 44, 85, 96,
    100–101
Five-second image challenge,
    100–107, 113
Flyers, 57–58, 97

**G**

Giveaways, 81, 114
Goals, establishing 19, 27, 40,
    43, 71, 73, 112
Greeting cards, 105–6

**H**

Halloween portraits, 110
Hartman, John, 9–13
Hasselblad University, 120–21
Hawkins, Jeff and Kathleen,
    108–11
Home shows, 44
Hook, 11–12, 19, 31–40, 44, 49,
    74, 85, 90–91, 97, 109

**I**

Image, importance of, 17–18,
    94–107
Infomercials, 80–81

Internet, 58–60, 117–18
Inventory levels, 30

**L**
Lewis, Charles, 70–77
Lifetime portrait program, 110
Lift card, 74
Literature, 57–58, 105, 113–4
   appearance of, 58, 97, 105
   comparing with others'
      marketing pieces, 105
   mailing lists, 58
   paper stock, 57
   proofreading, 58
Local economy, 16
Loss leaders, 78–79

**M**
MacGregor, Don, 41–45
Magazine ads, 50
Mailing lists, 58
Mall displays, 42, 44, 67
Management, 8, 42–43
"Me too" syndrome, 38, 54, 97
Mistakes, common, 97–100
Motivations, understanding
   your own, 7–8, 15–16

**N**
Networking, 21–23, 63–67
   with other photographers, 31,
      114–15
   with past and present clients,
      65–67, 88–89
   with related vendors, 63–65,
      85, 116
New ideas, implementing, 10
Newspaper ads, 44, 67, 105
Niche, finding your, 55–56

**O**
Operating capacity, 10
Ordering procedures, 30

**P**
Perceived value, 47, 69
Postcards, 9, 57–58, 97
Preselling, 41–42
Press releases, 62, 118

Price lists, 57–58, 97–98, 105
Price vs. purchasing desire, 42,
     60–62, 79, 80–81
Pricing, 29, 49–50, 60–62, 63,
     97–98, 102
Printing costs, 9–10
Priorities, setting, 8
Profit margins, 29, 98
Proofing, online, 59
Purchasing desire, 42

**Q**
Quality of life, 11, 22, 48–49,
     72–73, 82–83, 86

**R**
*Rangefinder*, 120
Redford, Michael, 21–24
Referrals, 59, 63–67, 88–89, 90
Reinventing your business, 28–30
Results, tracking, 17–18, 67, 114
Returning clients, 11

**S**
Sales skills, 38–39
Sample albums and images,
     103–4
Self employment, 7–8, 15–17, 28
Sense of humor, 25–27, 116–17
Service, *see* Customer Service
Slogans, 32, 35–36
Small-town studios, 16, 84, 106
Staff, *see* Employees
Strengths, evaluating your, 20, 30
Stress, 25–27, 116–17
Strickland, Mike, 19
Studio, appearance of, 29, 58,
     102–5
   amenities, 105
   camera room 104
   display samples, 103–4
   exterior, 102
   interior, 102–3, 105
   outdoor shooting areas, 104–5
   sales area, 103–4
   signage, 103
Studying marketing, 47
Successful efforts, 19, 42, 44, 51,
     110

Suppliers, 29, 98
Supply and demand, 71

**T**
Telephone, 67–69
   answering machine message,
     67–68, 90
   conversational skills, 69
   greeting callers, 68–69
   returning calls, 90
   tracking calls, 67, 114
Television commercials, 67
Testimonials, customer, 65
Thank-you notes, 105
Time
   management, 63, 89
   scheduling sessions, 48–49,
     62–63
   set aside for marketing, 20, 48,
     71, 89, 113
   value of your, 46, 88
Twelve-step program, 112–18

**U**
Understanding your business,
     18–20, 28–30
Unique qualities, conveying your,
     *see* Hook

**V**
Val-Pak inserts, 60
Value
   enhancing, 78–83
   perceived, 47, 69, 78–83
   purchasing incentives, 80

**W**
Weaknesses, evaluating your, 20,
     30
Web site, 58–60, 85, 90, 117–18
Wedding and Portrait Photog-
     raphers International
     (WPPI), 120
Workflow, digital, 46, 84

**Y**
Yellow pages, 12, 44, 60, 67, 72,
     90, 105

## Freelance Photographer's Handbook

*Cliff and Nancy Hollenbeck*

Whether you want to be a freelance photographer or are looking for tips to improve your current freelance business, this volume is packed with ideas for creating and maintaining a successful freelance business. $29.95 list, 8½x11, 107p, 100 b&w and color photos, index, glossary, order no. 1633.

## Corrective Lighting and Posing Techniques for Portrait Photographers

*Jeff Smith*

Learn to make every client look his or her best by using lighting and posing to conceal real or imagined flaws—from baldness, to acne, to figure flaws. $29.95 list, 8½x11, 120p, 150 color photos, order no. 1711.

## Studio Portrait Photography of Children and Babies, 2nd Ed.

*Marilyn Sholin*

Work with the youngest portrait clients to create cherished images. Includes techniques for working with kids at every developmental stage, from infant to preschooler. $29.95 list, 8½x11, 128p, 90 color photos, order no. 1657.

## Portrait Photographer's Handbook

*Bill Hurter*

Bill Hurter has compiled a step-by-step guide to portraiture that easily leads the reader through all phases of portrait photography. This book will be an asset to experienced photographers and beginners alike. $29.95 list, 8½x11, 128p, 100 color photos, order no. 1708.

## Marketing and Selling Black & White Portrait Photography

*Helen T. Boursier*

Complete manual for adding b&w portraits to the products you offer clients (or offering exclusively b&w). Learn to attract clients and deliver portraits that will keep them coming back. $29.95 list, 8½x11, 128p, 80 b&w photos, order no. 1677.

## Traditional Photographic Effects with Adobe® Photoshop®, 2nd Ed.

*Michelle Perkins and Paul Grant*

Use Photoshop to enhance your photos with handcoloring, vignettes, soft focus, and much more. Every technique contains step-by-step instructions for easy learning. $29.95 list, 8½x11, 128p, 150 color images, order no. 1721.

## Infrared Wedding Photography

*Patrick Rice, Barbara Rice and Travis Hill*

Step-by-step techniques for adding the dreamy look of black & white infrared to your wedding portraiture. Capture the fantasy of the wedding with unique ethereal portraits your clients will love! $29.95 list, 8½x11, 128p, 60 b&w images, order no. 1681.

## Master Posing Guide for Portrait Photographers

*J. D. Wacker*

Learn the techniques you need to pose single portrait subjects, couples, and groups for studio or location portraits. Includes techniques for photographing weddings, teams, children, special events and much more. $29.95 list, 8½x11, 128p, 80 photos, order no. 1722.

## Posing and Lighting Techniques for Studio Photographers

*J. J. Allen*

Master the skills you need to create beautiful lighting for portraits. Posing techniques for flattering, classic images help turn every portrait into a work of art. $29.95 list, 8½x11, 120p, 125 color photos, order no. 1697.

## High Impact Portrait Photography

*Lori Brystan*

Learn how to create the high-end, fashion-inspired portraits your clients will love. Features posing, alternative processing, and much more. $29.95 list, 8½x11, 128p, 60 color photos, order no. 1725.

## The Art of Bridal Portrait Photography

*Marty Seefer*

Learn to give every client your best and create timeless images that are sure to become family heirlooms. Seefer takes readers through every step of the bridal shoot, ensuring flawless results. $29.95 list, 8½x11, 128p, 70 color photos, order no. 1730.

## Beginner's Guide to Adobe® Photoshop®, 2nd Ed.

*Michelle Perkins*

Learn to effectively make your images look their best, create original artwork, or add unique effects to any image. Topics are presented in short, easy-to-digest sections that will boost confidence and ensure outstanding images. $29.95 list, 8½x11, 128p, 300 color images, order no. 1732.

## Lighting Techniques for High Key Portrait Photography

*Norman Phillips*

Learn to meet the challenges of high key portrait photography and produce images your clients will adore. $29.95 list, 8½x11, 128p, 100 color photos, order no. 1736.

## Professional Digital Photography

*Dave Montizambert*

From monitor calibration, to color balancing, to creating advanced artistic effects, this book provides those skilled in basic digital imaging with the techniques they need to take their photography to the next level. $29.95 list, 8½x11, 128p, 120 color photos, order no. 1739.

LIGHTING AND EXPOSURE TECHNIQUES FOR
## Outdoor and Location Portrait Photography

*J. J. Allen*

Meet the challenges of changing light and complex settings with techniques that help you achieve great images every time. $29.95 list, 8½x11, 128p, 150 color photos, order no. 1741.

## The Art and Business of High School Senior Portrait Photography

*Ellie Vayo*

Learn the techniques that have made Ellie Vayo's studio one of the most profitable senior portrait businesses in the US. $29.95 list, 8½x11, 128p, 100 color photos, order no. 1743.

## The Art of Black & White Portrait Photography

*Oscar Lozoya*

Learn how Master Photographer Oscar Lozoya uses unique sets and engaging poses to create black & white portraits that are infused with drama. Includes lighting strategies, special shooting techniques and more. $29.95 list, 8½x11, 128p, 100 duotone photos, order no. 1746.

## The Best of Wedding Photography

*Bill Hurter*

Learn how the top wedding photographers in the industry transform special moments into lasting romantic treasures with the posing, lighting, album design, and customer service pointers found in this book. $29.95 list, 8½x11, 128p, 150 color photos, order no. 1747.

## Success in Portrait Photography

*Jeff Smith*

Many photographers realize too late that camera skills alone do not ensure success. This book will teach photographers how to run savvy marketing campaigns, attract clients, and provide top-notch customer service. $29.95 list, 8½x11, 128p, 100 color photos, order no. 1748.

## The Best of Children's Portrait Photography

*Bill Hurter*

*Rangefinder* editor Bill Hurter draws upon the experience and work of top professional photographers, uncovering the creative and technical skills they use to create their magical portraits. $29.95 list, 8½x11, 128p, 150 color photos, order no. 1752.

## Web Site Design for Professional Photographers

*Paul Rose and Jean Holland-Rose*

Learn to design, maintain, and update your own photography web site. Designed for photographers, this book shows you how to create a site that will attract clients and boost your sales. $29.95 list, 8½x11, 128p, 100 color images, index, order no. 1756.

PROFESSIONAL PHOTOGRAPHER'S GUIDE TO
## Success in Print Competition

*Patrick Rice*

Learn from PPA and WPPI judges how you can improve your print presentations and increase your scores. $29.95 list, 8½x11, 128p, 100 color photos, index, order no. 1754.

# Also from
# Featured Contributors . . .

## Wedding Photography
CREATIVE TECHNIQUES FOR
LIGHTING AND POSING, 2nd Ed.
*Rick Ferro*

Creative techniques for lighting and posing wedding portraits that will set your work apart from the competition. Covers every phase of wedding photography. $29.95 list, 8½x11, 128p, 80 color photos, index, order no. 1649.

## Wedding Photography with Adobe® Photoshop®
*Rick Ferro and Deborah Lynn Ferro*

Get the skills you need to make your images look their best, add artistic effects, and boost your wedding photography sales with savvy marketing ideas. $29.95 list, 8½x11, 128p, 100 color images, index, order no. 1753.

## Professional Secrets for Photographing Children 2nd Ed.
*Douglas Allen Box*

Covers every aspect of photographing children, from preparing them for the shoot, to selecting the right clothes to capture a child's personality, and shooting storybook themes. $29.95 list, 8½x11, 128p, 80 color photos, index, order no. 1635.

## Professional Secrets of Natural Light Portrait Photography
*Douglas Allen Box*

Use natural light to create hassle-free portraiture. Beautifully illustrated with detailed instructions on equipment, lighting, and posing. $29.95 list, 8½x11, 128p, 80 color photos, order no. 1706.

## Professional Secrets of Wedding Photography 2nd Ed.
*Douglas Allen Box*

Top-quality portraits are analyzed to teach you the art of professional wedding portraiture. Lighting diagrams, posing information, and technical specs are included for every image. $29.95 list, 8½x11, 128p, 80 color photos, order no. 1658.

## Professional Marketing & Selling Techniques for Wedding Photographers
*Jeff Hawkins and Kathleen Hawkins*

Learn the business of wedding photography. Includes consultations, direct mail, advertising, internet marketing, and much more. $29.95 list, 8½x11, 128p, 80 color photos, order no. 1712.

## Professional Techniques for Digital Wedding Photography, 2nd Ed.
*Jeff Hawkins and Kathleen Hawkins*

From selecting equipment, to marketing, to building a digital workflow, this book teaches how to make digital work for you. $29.95 list, 8½x11, 128p, 85 color images, order no. 1735.

## Digital Photography for Children's and Family Portraiture
*Kathleen Hawkins*

Discover how digital photography can boost your sales, enhance your creativity, and improve your studio's workflow. $29.95 list, 8½x11, 128p, 130 color images, index, order no. 1770.

PHOTOGRAPHER'S GUIDE TO
## Wedding Album Design and Sales
*Bob Coates*

Enhance your income and creativity with these techniques from top wedding photographers. $29.95 list, 8½x11, 128p, 150 color photos, index, order no. 1757.

## The Best of Portrait Photography
*Bill Hurter*

View outstanding images from top professionals and learn how they create their masterful images. Includes techniques for classic and contemporary portraits. $29.95 list, 8½x11, 128p, 200 color photos, index, order no. 1760.

### THE ART AND TECHNIQUES OF
## Business Portrait Photography
*Andre Amyot*

Learn the business and creative skills photographers need to compete successfully in this challenging field. $29.95 list, 8½x11, 128p, 100 color photos, index, order no. 1762.

## The Best of Teen and Senior Portrait Photography
*Bill Hurter*

Learn how top professionals create stunning images that capture the personality of their teen and senior subjects. $29.95 list, 8½x11, 128p, 150 color photos, index, order no. 1766.

### PHOTOGRAPHER'S GUIDE TO
## The Digital Portrait
### START TO FINISH WITH ADOBE® PHOTOSHOP®
*Al Audleman*

Follow through step-by-step procedures to learn the process of digitally retouching a professional portrait. $29.95 list, 8½x11, 128p, 120 color images, index, order no. 1771.

## The Portrait Book
### A GUIDE FOR PHOTOGRAPHERS
*Steven H. Begleiter*

A comprehensive textbook for those getting started in professional portrait photography. Covers every aspect from designing an image to executing the shoot. $29.95 list, 8½x11, 128p, 130 color images, index, order no. 1767.

## Professional Strategies and Techniques for Digital Photographers
*Bob Coates*

Learn how professionals—from portrait artists to commercial specialists—enhance their images with digital techniques. $29.95 list, 8½x11, 128p, 130 color photos, index, order no. 1772.

## Lighting Techniques for Low Key Portrait Photography
*Norman Phillips*

Learn to create the dark tones and dramatic lighting that typify this classic portrait style. $29.95 list, 8½x11, 128p, 100 color photos, index, order no. 1773.

## The Best of Wedding Photojournalism
*Bill Hurter*

Learn how top professionals capture these fleeting moments of laughter, tears, and romance. Features images from over twenty renowned wedding photographers. $29.95 list, 8½x11, 128p, 150 color photos, index, order no. 1774.

## Portrait Photography
### THE ART OF SEEING LIGHT
*Don Blair with Peter Skinner*

Learn to harness the best light both in studio and on location, and get the secrets behind the magical portraiture captured by this award-winning, seasoned pro. $29.95 list, 8½x11, 128p, 100 color photos, index, order no. 1783.

## Posing for Portrait Photography
### A HEAD-TO-TOE GUIDE
*Jeff Smith*

Author Jeff Smith teaches sure-fire techniques for fine-tuning every aspect of the pose for the most flattering results. $29.95 list, 8½x11, 128p, 150 color photos, index, order no. 1786.